SURFACES
& SUPPORTS

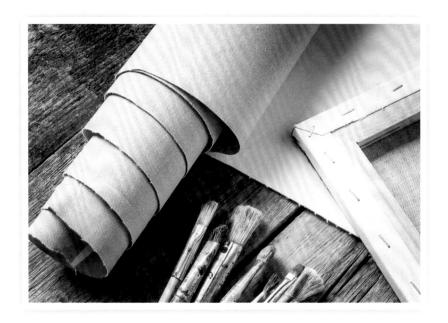

A practical guide to

DRAWING AND PAINTING SURFACES—
from canvas and paper to textiles and woods

Brimming with creative inspiration, how-to projects, and useful information to enrich your everyday life, Quarto Knows is a favorite destination for those pursuing their interests and passions. Visit our site and dig deeper with our books into your area of interest: Quarto Creates, Quarto Cooks, Quarto Homes, Quarto Lives, Quarto Drives, Quarto Explores, Quarto Gifts, or Quarto Kids.

Photograph on page 10 courtesy of Laguna Art Supply Store. Artwork and photographs on pages 11–16, 17 ("Watercolor Paper"), 18, 19, 20 ("Rice Paper"), 21 ("Washi Paper," Washi Tape"), 24 ("Gallery-Wrapped Canvas," "Canvas Board"), 25, 26 (canvas board), 27–33, 37–39, 44, 52–53, 55, 63–66, 68–69, 77–79, 82, 85, 87–91 ("B"), 83, 96, 97, 98 (acrylic dispersion ground, bottom photo),. 99, 102, and 103 © Elizabeth T. Gilbert. Artwork on page 17 (cactus) © Kristin Van Leuven. Artwork on page 21 (mixed media) © Cherril Doty and Marsh Scott. Artwork and photographs on pages 43, 46 (bottom), 49, and 50 © Christine Mariotti. Artwork and photographs on pages 54, 56, and 57 © Candice Bohannon. Artwork and photographs on pages 60 and 61 © Susan von Borstel. Photographs on page 71 courtesy of DecoArt. Photograph on page 72 courtesy of Grafix. Artwork on page 73 © Mindy Lighthipe. Artwork on pages 78 and 86 © Jim Dowdalls. Artwork on page 79 © Chelsea Ward. Artwork on page 84 (top) © Eileen Sorg. Artwork on page 84 (bottom) © Cynthia Knox. Artwork on page 92 © Joy Laforme. Artwork on page 93 © Tom Swimm. Artwork on page 94 © James Sulkowski. Artwork on pages 104–107 © Barbara Polc. Artwork on pages 108–111 © Blakely Little. All other images © Shutterstock.

Thank you to the Colorado Springs Fine Arts Center at Colorado College for allowing us to photograph kilns, pottery, and the glazing process.

Thank you to JD Sell and HR Meininger Co. of Colorado Springs for allowing us to photograph the canvas stretching process.

First published in 2019 by Walter Foster Publishing, an imprint of The Quarto Group.
26391 Crown Valley Parkway, Suite 220, Mission Viejo, CA 92691, USA.
T (949) 380-7510 **F** (949) 380-7575 **www.QuartoKnows.com**

Walter Foster Publishing titles are also available at discount for retail, wholesale, promotional, and bulk purchase. For details, contact the Special Sales Manager by email at specialsales@quarto.com or by mail at The Quarto Group, Attn: Special Sales Manager, 100 Cummings Center, Suite 265D, Beverly, MA 01915, USA.

ISBN: 978-1-63322-608-1

Digital edition published in 2019
eISBN: 978-1-63322-609-8

Acquiring & Project Editor: Stephanie Carbajal

Printed in China
10 9 8 7 6 5 4 3

TABLE OF CONTENTS

Introduction

When praising a work of art, we often give all the credit to the medium and the design. We immediately appreciate color, composition, and style without mentioning what lies at the foundation of it all: the drawing or painting surface. Also called a "support" (and rightly so), the underlying surface helps determine several important qualities of the work—from texture, brightness, and luminosity to longevity. Your choice of surface can also contribute conceptually by strengthening the overall theme, such as painting scenes of nature on stone or weathered wood.

Paper, canvas, and wood panels are the most common drawing and painting supports, but don't feel pressured into a traditional approach. Artists throughout the centuries have explored (and found success with) a variety of surfaces, including animal skins, fabrics, and sheet metal. However, the more you understand why and how artists work with particular surfaces, the more likely you are to find success with your own artistic decisions. Use this book as a general guide, but don't be afraid to experiment!

Meet the Artists

A lifelong lover of the arts, **Elizabeth T. Gilbert** earned a BA in English from the University of San Diego in 2003, where she also studied art. Elizabeth spent the following eight years as an editor, a writer, and an in-house artist for Walter Foster Publishing, where she developed a fondness for experimenting with a wide range of art media. She is now a freelance writer, editor, and illustrator based in Colorado.

Contributors

Candice Bohannon Reyes was raised in the rural forested landscape of the foothills of the Sierra Nevada mountains, and her naturalistic aesthetic in art was honed from an early age. Candice studied painting, drawing, sculpting, art history, philosophy, and aesthetics, graduating from the Laguna College of Art and Design in 2005 with a BFA in painting/drawing and a minor in sculpture. Candice lives in Northern California with her husband and fellow artist Julio Reyes. Visit www.candicebohannon.com.

Artist **Blakely Little** delights in the scenery of coastal towns—their pastel palettes, winding waterways, and upbeat moods. Based in Charleston, South Carolina, she paints the world in unlikely colors meant to inspire a sense of discovery and joy. Visit www.blakelymade.com.

Inspired by the beauty of landscapes, seascapes, and the sky, **Barbara Polc** works in a broad spectrum of mediums: alcohol inks, acrylics, collage, encaustics, and watercolors. Born and raised in Upstate New York, Barbara now resides in Ontario, Canada. Visit www.barbarapolc.com.

Susan von Borstel is an internationally known artist of horses, wildlife, and people. Susan grew up crazy about horses and wild about art. She started painting and drawing horses at a young age and went on to receive a BA from the University of Colorado in zoology and art. Susan creates original artwork on natural stone with oil paints. Visit susanvonborstel.com.

Chapter 1:
Paper

Over the years, paper has become an invaluable tool for recordkeeping and artmaking. Today, a variety of papers are both affordable and readily available. In the pages that follow, we'll look at the papers that offer the most practical surfaces for drawing and painting.

PAPER PROPERTIES

Material The majority of paper today is made out of cellulose fibers derived from wood pulp, cotton, or a blend of the two. Generally speaking, the higher the cotton content, the higher the paper quality. Papers made of 100-percent cotton are more durable and less likely to become brittle or yellow over time. Papers made from cotton rags are called "rag paper"; these strong sheets are made up of the longest cotton fibers. However, most cotton paper is made of cotton linter (shorter fibers) or a combination of rag and linter. Wood pulp paper is more affordable than cotton paper, and modern techniques for reducing the acid content make this option more appealing to artists.

Some papers are manufactured with an ingredient called "sizing" or "size." Sizing—which is usually gelatin or animal glue—changes the way a paper accepts a medium. The more sizing a paper has, the less likely it is to absorb moisture and pigment. Papers made specifically for ink or marker often have a good amount of internal sizing, which means that the sizing is mixed in with the pulp before the paper dries. This makes the ink less likely to bleed through or across the paper while keeping the color vibrant. Many watercolor papers are also coated with surface sizing, giving the artist control over the washes. (See "Sizing," page 18.) Sizing also keeps the paper from buckling under moisture.

Weight Paper weight is measured in either pounds (lb) per ream (500 sheets) or grams per square meter (gsm or g/m2). The measurement system of pounds depends on a sheet's size and varies between paper types, so there is no "across the board" conversion method for matching lb. and gsm. Using gsm to describe a paper's weight is more consistent and perhaps more descriptive; however, the pound system is more common in the United States. Below are some of the most readily available paper types and weights, listed in both lb and approximate gsm. Remember: The greater the lb or gsm, the thicker the paper.

RAG PAPER IN ACTION

Aside from art, rag paper is used for important documents that need to last or withstand wear and tear. Paper money, which endures plenty of abuse and folding, is made of rag paper.

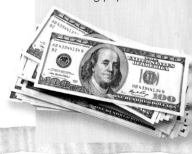

35 lb. / 50 gsm	Newsprint
45 lb. / 60 gsm	Kraft paper
60 lb. / 90 gsm	Sketching paper
80 lb. / 130 gsm	Drawing paper
100 lb. / 260 gsm	Heavy drawing paper

STANDARD PAPER WEIGHTS

Go Acid-Free! You may notice that some papers and canvases are labeled "acid-free." This desirable quality will help your artwork stand the test of time. Technically speaking, an acid-free surface has a pH of 7 or higher. To the artist, this means that the surface will not yellow or deteriorate as time passes. Some papers are buffered, which means they were manufactured with an alkaline additive to neutralize the paper. Unless you're drafting rough sketches, make it a point to work on acid-free surfaces. You never know which pieces you'll want to last!

BRIGHTNESS & COLOR

Art papers are available in nearly every color imaginable. However, most artists work on papers that range from bright white to cream, which provide light, clean surfaces that contrast well with graphite, charcoal, and other dark media. The brighter the surface, the brighter your colors and highlights will appear in the final work. You can also subtly alter the temperature of your overall work by choosing a paper that leans warm or cool. Remember that any medium you use will be influenced by the brightness and color of the support beneath.

Some artists like working on toned paper, with the most common choices being gray and tan. Artists use the tone of the paper as a middle value and apply the highlights and shadows using charcoal or Conté crayon. This is a quick way to develop a drawing that often produces dramatic results.

Texture & Finish To understand texture and finish, run your finger across several different papers. They can be glossy, bumpy, smooth, or ribbed. Aside from the actual feel of the paper, the surface quality plays a role in how the paper responds to and accepts the medium. Below are the most common terms relating to texture and finish.

Smooth, Medium & Rough Paper textures are generally described as smooth, medium, or rough. Rough papers have a prominent tooth, which refers to the bumps and grooves on the paper's surface. These raised areas catch your medium as you stroke across the paper. Smooth papers have little to no tooth, and medium papers have a tooth somewhere between rough and smooth. Dry mediums, such as pencil, charcoal, and pastel, rely on some tooth in order to adhere to the paper. The more tooth a paper has, the rougher your pencil or brushstroke will be and the more medium will catch on the paper. Papers with a fine tooth yield rich, dark colors when working with dry media; rough papers with a large tooth yield coarse strokes and complement an expressive, painterly style. However, more tooth is not necessarily better. Papers with minimal tooth are best for artists who work in fine detail, as smooth surfaces give artists more control over their media.

Media on Paper Textures

Graphite pencil 2B gradation on smooth paper

Graphite pencil 2B gradation on medium paper

Graphite pencil 2B gradation on rough paper

Soft pastel on smooth paper

Soft pastel on medium paper

Soft pastel on rough paper

Laid-Finish Paper Papers with a laid finish feature fine, parallel grooves that simulate "chain lines" characteristic of old pressed, handmade papers. The grooves catch the drawing medium and give the artwork a ribbed texture. Charcoal, pastel, Conté crayon, chalk, and soft graphite work well with laid surfaces.

Wove Finish Papers with a wove finish are smooth with a subtle woven or mesh pattern. It is the standard finish for papers used for printing and writing, such as stationery. The uniform surface affords artists a good amount of control over a medium.

Matte vs. Gloss Two common words used to describe the finish of a paper are "matte" and "gloss." In almost all cases, artist paper has a matte or "uncoated" finish, which is nonreflective and receptive to wet and dry media. Gloss paper is slick and reflective; the lack of friction makes it difficult to accept and control a medium. It can also cause smearing and show fingerprints. Gloss paper can work for calligraphy or pen and ink, but it is mainly used for printing purposes. If you want your artwork to have a gloss finish, consider working on matte paper and then sealing your drawing with a gloss varnish.

Charcoal on laid paper

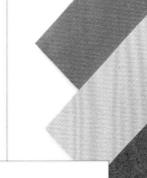

Toned & mesh-textured pastel papers

FORMATS

Paper comes in a variety of formats, and your choice should depend on your requirements and personal taste. Below is a breakdown of available formats.

Paper is available in loose sheets, rolls, and various pads. For sketching on site, you might opt to work in a pad; for a finished work meant for framing, you may want to work on a loose sheet.

Pads & Books Paper pads consist of a stack of papers on a firm cardboard backing, which allows you to sketch without a table if needed. The papers are attached along one edge with tape, glue, or a plastic or metal spiral. These formats are available in a range of manageable sizes that suit artists on-the-go. However, many artists choose to remove single sheets and work on another surface to prevent indentations transferring to the papers beneath.

Rolls Paper is available in rolls, often a cheaper option per square inch than pads or loose sheets of paper. However, the savings may not be worth the time involved in cutting your own sheets. Also, paper that has been freshly cut from a roll has a tendency to curl.

Loose Sheets For a serious drawing, loose sheets are a great choice because they have clean, ready-to-display edges. This format also allows you to experiment with different paper types without having to buy multiple sheets of the same surface.

TIP

A good, convenient drawing paper choice for beginners is an 80-lb., 9" x 12" pad.

If you choose to work in a spiral pad, purchase one with perforated pages. This allows you to gently remove sheets while creating a clean, untorn edge.

TYPES OF PAPER

The next few pages highlight the most common types of paper available to artists. Remember that you are not limited to the suggestions in this book, and some surfaces may suit you and your medium in a way not described.

Newsprint Newsprint is a thin, inexpensive drawing surface that is perfect for creating loose sketches. Artists often use newsprint for gesture drawing and thumbnail studies. Available in pads and rolls, newsprint has a gray tone and a surface that allows you to work quickly in long, gliding strokes. Newsprint comes in rough and smooth surfaces, and both work well with graphite and colored pencil. Rough newsprint also accepts media such as charcoal or crayon. Newsprint does not hold up well to erasures and does not have a long lifespan, as it is acidic.

Kraft Paper A strong paper made of wood pulp, kraft paper (also referred to as "butcher paper") is most commonly available in various shades between white and brown. Some artists prefer the warm tones of this paper for sketching and gestural drawings. Because kraft paper is inexpensive, artists can draw without worrying about wasting fine paper. It usually comes in rolls, although it's also found in pads and spiral notebooks.

Drawing Paper This large category covers paper that is suitable for graphite and other dry media. Drawing paper varies widely in weight, from 50 lb. to roughly 106 lb. Thin papers between 50 lb. and 64 lb. are great for sketching, whereas heavier weights can withstand more erasures and are more appropriate for serious drawings. Drawing papers generally range in color from bright white to various creams, although you can find a variety of colorful tones to choose from.

Most drawing paper is machine-made and available in pads and loose sheets. You can also purchase drawing paper in a roll, which is an economical option that's most convenient when you need large, irregular-sized sheets.

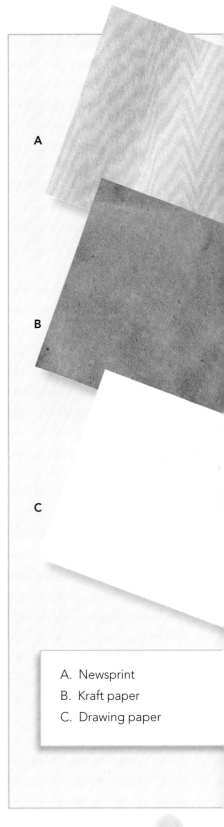

A

B

C

A. Newsprint
B. Kraft paper
C. Drawing paper

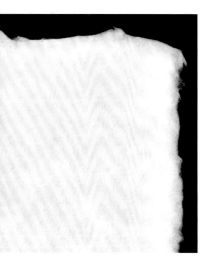

Handmade Paper Some artists prefer the uniform surfaces of machine-made papers, but others enjoy working on more organic handmade surfaces. Handmade papers are visually distinct because they feature deckle edges, which are soft, feathery, irregular edges formed by the natural thinning of the paper.

Machine-made papers are manufactured in rolls—a process that aligns the fibers in one direction, resulting in a grain that makes the paper stronger in one direction than the other. Handmade papers are made individually and do not have a discernible grain, making them stronger, and are less likely to tear, curl, or buckle.

Mould-Made Paper This paper is a hybrid of machine-made and handmade papers. During manufacturing, the screens are not shaken by hand, but the mold rotates so the fibers do not align and produce a grain. This gives the paper the even strength of handmade paper without the need for human touch. These sheets generally have two true deckle edges and two imitation deckle edges, often created by separating sheets of paper using a jet stream of water.

Once an inevitable result of the old papermaking process, deckle edges are now a desirable decorative element and a symbol of high quality.

Bristol Board This popular surface is thick, sturdy, and made up of multiple layers of paper (2-ply, 3-ply, or 4-ply). The sheets are wood pulp, cotton, or a combination of the two. Sometimes called "Bristol paper," Bristol board is named for its city of origin—Bristol, England. It features two drawing surfaces: plate finish on one side and vellum finish on the other. The plate side has a very smooth texture that works best with graphite, pen and ink, and even airbrush. The vellum side is rougher and works best with dry media that requires some tooth. Bristol board is available in several sizes and dimensions.

BRISTOL BOARD COMPARISON

Graphite pencil (2B) on the vellum side of Bristol paper

Graphite pencil (2B) on the plate side of Bristol paper

Illustration Board Illustration board is a general term that refers to thick, multi-ply paper or paper mounted to a hard core, creating a sturdy surface that does not easily crease, warp, or curl under dry media. Most often available in bright white, illustration board can have a surface of wood pulp, cotton, or a combination and is available in a variety of textures. Generally speaking, artists use illustration board for work that they plan to scan or photograph. It is not often used for work intended to last a long time. However, there are acid-free, 100-percent rag illustration boards that are optimal for longevity.

TIP Some artists use illustration board with wet media. However, illustration-board paper varies between manufacturers, and some do not feature sizing or a primer to make it accept the paint effectively. If you choose to use it with wet media, consider painting an "X" on the back to curb warping. Remember to read the manufacturer's medium suggestions as well.

Marker Paper When it comes to markers, the most important surface quality is the amount of control it gives you. Marker paper has a smooth surface ideal for achieving the crisp, graphic look of marker drawing. It is coated to minimize absorption, which prevents the ink from bleeding through and feathering across the paper and allows for layering and mixing. Marker paper can range from 50 lb. to more than 100 lb., with lower weights making it possible to trace from an image beneath. This paper is a top surface choice for manga and cartoon artists.

MARKER PAPER COMPARISON

Marker on marker paper produces crisp lines that don't bleed. The paper also allows for layering to darken a marker's value.

Marker on unsized, cold-pressed paper produces rough lines that readily bleed into the fibers, creating dark, irregular strokes.

Vellum Paper The term "vellum" can refer to the finish of a surface (such as Bristol board; see page 14), but in this case it refers to a translucent paper. The translucent quality of this durable surface makes it a good choice for technical drawing or tracing. Although the surface accepts graphite and other dry media, its transparent nature does not offer the brightest surface. Vellum works well with pen and ink, as it allows for smooth, crisp lines and fine detail. Oil can disrupt washes, so avoid placing fingerprints on the surface when using vellum paper.

*Vellum
Paper*

PAPER GUIDE QUICK SPECS

Newsprint	• Properties: gray, rough, or smooth • Uses: sketching, studies • Compatible Media: graphite pencil, colored pencil, charcoal, Conté crayon • Weight: 20–35 lb.
Kraft Paper	• Properties: sturdy, often neutral-colored • Uses: sketching, studies, and rough drawings • Compatible Media: dry media • Weight: 45–60 lb.
Drawing Paper	• Properties: bright white, neutrals, and colors • Uses: sketches and serious drawings • Compatible Media: dry media • Weight: 45–60 lb. for sketching; 70 lb. + for drawing
Bristol Board	• Properties: primarily white; plate (smooth) or vellum (rough) finishes • Uses: serious drawings • Compatible Media: dry media, pen and ink, airbrush • Weight: heavy weight; 2-ply, 3-ply, or 4-ply
Illustration Board	• Properties: bright white, thick • Uses: drawings; often used for reproduction • Compatible Media: dry media, pen and ink • Weight: variety of board thicknesses
Marker Paper	• Properties: white, smooth, and translucent • Uses: marker renderings • Compatible Media: marker, pen and ink • Weight: 50–100 lb.
Vellum Paper	• Properties: transparent • Uses: drawings, tracings • Compatible Media: pencil, pen and ink • Weight: thickness varies

Watercolor Paper Watercolor paper is the perfect surface for fluid washes of watercolor. However, many artists also like using this durable surface for other wet and dry media such as gouache, acrylic, pastel, pen and ink, and even graphite. Watercolor paper is available in single sheets, pads, blocks, and boards (watercolor paper mounted on firm board). Standard individual sheet sizes and weights most common to art-supply stores are outlined in the charts below. Watercolor paper is available in three textures: hot-pressed, cold-pressed, and rough. The surface you choose depends on your painting style and the visual effects you want to achieve.

Standard Sizes:	Standard Weights:	WATERCOLOR PAPER STANDARDS
11" x 15": quarter sheet	90 lb. / 190 gsm	
15" x 22": half sheet	140 lb. / 300 gsm	
22" x 30": full or Imperial sheet	260 lb. / 356 gsm	
27½" x 40": double elephant sheet	300 lb. / 638 gsm	

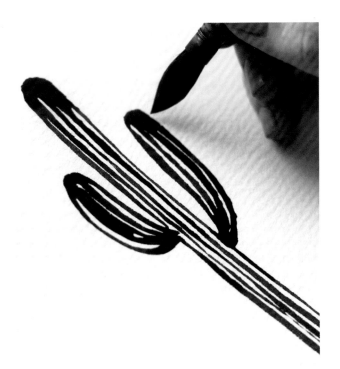

Use the white of the paper as much as possible. It's hard to add white back into a painting, so you must either paint around the areas you want to keep white or use masking fluid.

Artwork by Kristin Van Leuven

Sizing Watercolor papers feature sizing in varying degrees. The more sizing a paper contains, the less absorbent the paper is—and the less likely your washes are to bleed. Paper that is heavily sized is called "hard-sized." This stiff-to-the-touch paper gives optimal control over your washes and allows for plenty of mixing on the paper's surface. Hard-sized sheets can also handle rougher treatment such as erasures, application of masking fluid, and "lifting out" techniques.

Surface-sized watercolor paper makes it easier to rework strokes and lift off pigment from the surface using a wet brush.

Paper that does not have surface sizing is more absorbent, making paint more likely to bleed and less likely to lift from the surface.

Masking Fluid Also called "liquid frisket," masking fluid preserves the white of the paper while you paint. This allows you to stroke freely without working around highlights. Masking fluid can be colored or colorless and rub-away or permanent. Hard-sized paper stands up better to the removal process.

Acrylic Paper Acrylic paper is a heavyweight paper that is sized and textured to create an effective support for acrylic paint that doesn't warp. It's sold in pads and offers an inexpensive alternative to canvas or panel. Some acrylic paper is made with a finish that mimics linen canvas, giving it a good tooth for holding the paint and creating textured strokes. You might also find this paper to be an effective support for dry media, such as pastel and charcoal.

Acrylic paper with two acrylic strokes: undiluted paint (left) and thinned paint (right).

Mixed Media Paper This paper is a thick and well-sized paper that accepts both wet and dry media. It's available in fine to rough textures.

Medium-textured mixed media paper showing (from top to bottom) acrylic, gouache, watercolor, colored pencil, soft pastel, oil pastel, and graphite pencil.

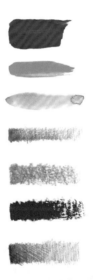

Canvas Paper Canvas paper is a thick, primed paper that features a gridlike canvas texture. It's less bulky and more affordable than stretched canvas, which makes it great for practice paintings and experimentation. Available in pads, most canvas papers are grounded for both acrylic and oil paint.

Rice Paper Rice paper refers to thin, absorbent paper used for Chinese brush painting, calligraphy, and sometimes Japanese sumi-e painting. Also called "Xuan paper," this soft, lightly grained surface is made from a mix of wood pulp and rice straws. It's generally white, cream, or light gray.

Because these papers are often made without sizing, the fibers quickly absorb ink and yield softly blurred edges. Instead of complex blends, workable washes, and rolling droplets of paint that you can achieve on sized watercolor paper, rice papers allow for broken, energetic strokes that soak right into the surface. This creates an immediacy and freshness that is central to the ideas behind both Chinese brush and Japanese sumi-e. Sized and semi-sized rice papers, however, are better for small strokes and tight calligraphy.

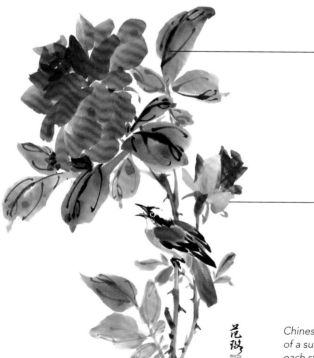

The fine grain of the rice paper shows subtle texture within washes and allows for lively, broken strokes.

The lack of sizing in rice paper produces blurred edges and creates a soft, spontaneous quality.

Chinese brush is about capturing the essence of a subject in an expressive, minimalist style—each stroke counts!
Artwork by Lucy Wang

Washi Paper Washi paper was originally made as the traditional surface for Japanese sumi-e painting. Made from sturdier wood fibers, such as mulberry, hemp, or bamboo, this paper is durable but can also be made in translucent sheets of a variety of colors and patterns. It has a delicately webbed texture and is sometimes made with flowers or leaves pressed into it. These decorative, lightweight papers are ideal for layering in collage or mixed media works. They are also used for the Japanese art of origami.

Washi tape is simply washi paper in adhesive strips. Available in rolls, this format simplifies the crafting and collaging process with washi paper. It also comes in a range of playful colors and patterns—perfect for boldly embellishing a work of art.

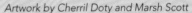

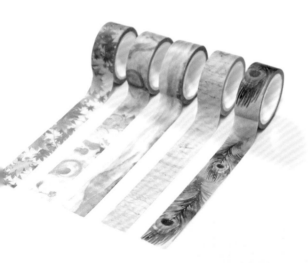

Washi Tape

Artwork by Cherril Doty and Marsh Scott

21

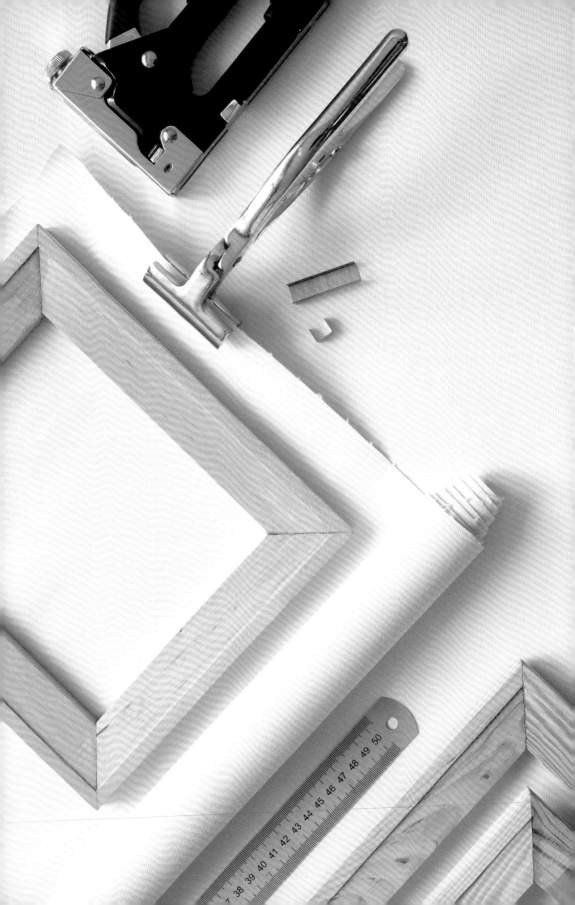

Chapter 2:

Canvas

Canvas is lightweight, portable, and affordable. It also allows great freedom with artwork size; many famous large-scale paintings were completed on canvases, including Claude Monet's *Water Lilies* series and Pablo Picasso's *Guernica*. Canvas has been used as a painting surface for more than 600 years, and today it is considered the most popular painting surface for oil and acrylic.

Composition & Formats

Canvas is made up of tightly woven fibers that create a thick, sturdy fabric. The first canvases were made of hemp, which is still used today; however, more common fibers include cotton and linen. Cotton (sometimes referred to as "cotton duck") is more affordable and flexible, whereas linen (or "linen duck") is strong but expensive. Most canvases in stores today are made of cotton. Some manufacturers also incorporate synthetic fibers, such as polyester and rayon, into their canvas.

Formats

For beginning artists, the easiest way to use canvas is to purchase a pre-stretched and pre-primed canvas. Although costly, these surfaces require no assembly and no surface preparation. They are available in a variety of sizes and proportions at any art-supply store or online. These ready-made canvases are most often gallery wrapped, which is canvas pulled taut over a wooden frame and stapled on the back to leave a clean, canvas-covered front and sides. You can mount these canvases without worrying about a frame. Below are the most commonly available formats of canvas.

CANVAS FORMATS

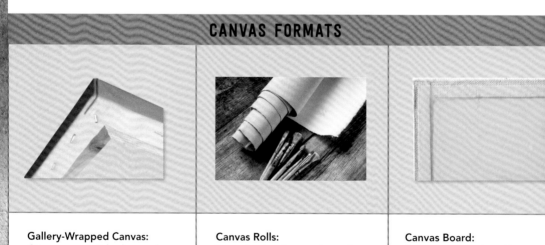

Gallery-Wrapped Canvas:
Canvas pre-stretched around wooden stretcher bars, available pre-primed and unprimed.

Canvas Rolls:
Long sheets of canvas in a roll, allowing artists to cut any desired length for stretching. It is available pre-primed and unprimed.

Canvas Board:
Canvas mounted on thin, hard board and pre-primed. (Back shown.)

Below you can see linen and cotton canvas materials. They are available in bulk rolls, either primed or unprimed. When it comes time to choose a type of canvas, remember this: the tighter the weave, the smoother the surface and the better suited the canvas is for detailed painting styles. Looser weaves create more textured surfaces that suit more expressive approaches.

TIP

Some art stores sell stretched burlap canvases. This chunky weave is best for crafting, stamping, and mixed media works that call for plenty of texture and a vintage flair.

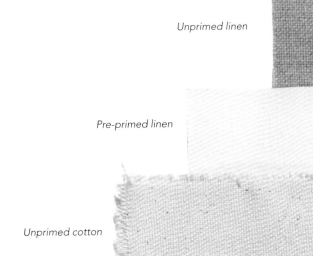

Unprimed linen

Pre-primed linen

Unprimed cotton

Pre-primed cotton

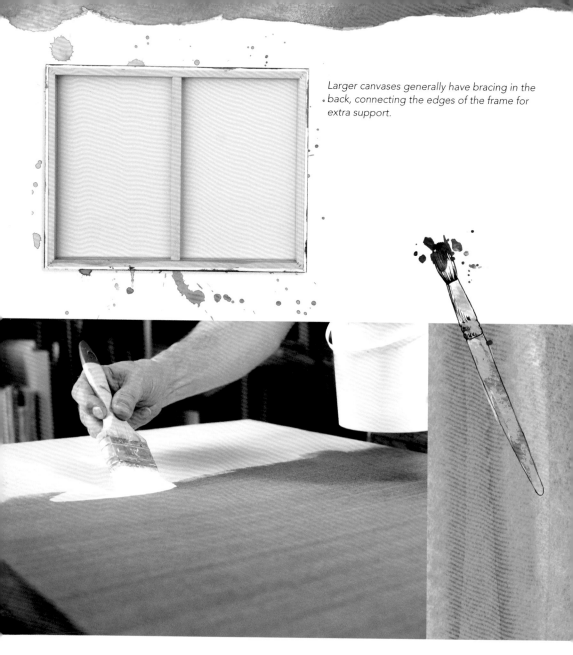

Larger canvases generally have bracing in the back, connecting the edges of the frame for extra support.

PRIMING CANVAS

Canvas fibers are very absorbent and susceptible to rotting when exposed to moisture and oils. As a result, it's crucial to prep and prime your canvas before painting. If you have an unprimed canvas, apply layers of an acrylic dispersion ground or a layer of sizing followed by an oil ground.

Stretching a Gallery-Wrapped Canvas

Although pre-stretched canvases are readily available at art-supply stores, some artists prefer to stretch their own. This gives them complete control over the choice of materials and the tension of the canvas surface. The most common form of stretched canvas is gallery-wrapped, which features canvas stretched over all edges of a wooden frame without any visible staples. This type of canvas can be hung simply and viewed from any angle. Follow the steps to stretch your own gallery-wrapped canvas.

You'll need the following materials:

1. Stretcher pliers (also called "canvas pliers") for pulling canvas taut over the frame
2. Staple gun and staples (manual or electrical) for securing the canvas to the frame
3. Fabric scissors for cutting the canvas
4. Gloves to protect your hands
5. Measuring tape and pencil for measuring and marking the canvas
6. Straightedge for marking scissor guidelines on the canvas
7. Awl for removing staples
8. Needle-nose pliers for removing staples and pulling the canvas at its corners

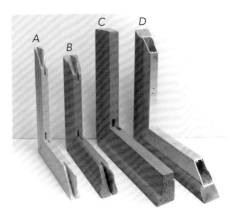

Stretcher pliers

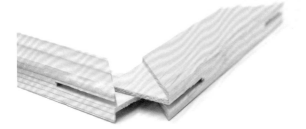

Stretcher bars are assembled by connecting a tongue-and-groove joint at a right angle, which you can reinforce with staples.

Stretcher bars come in a few weights:

- Studio (A): Also called "lightweight," these stretcher bars have a depth (or profile) of less than 1 inch. These are best for canvases that are smaller than 24 inches tall or wide.

- Gallery (B): Also called "mediumweight," these stretcher bars have a depth of roughly 1½ to ¾ inches.

- Deep (C): Also called "heavyweight," these stretcher bars generally have a 2-inch profile. They are also available with aluminum bracing to prevent warping (D).

 TIP Any canvas with a length or width of 36 inches or more should feature a cross brace (supportive strips of wood across the back) to reduce warping.

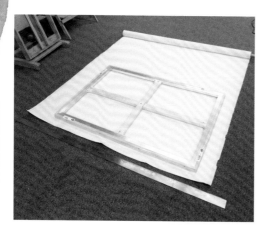

STEP 1

Choose your canvas material (usually cotton or linen), and decide whether to work with primed or unprimed canvas. In this demonstration, the artist is using pre-primed cotton canvas (12 oz.) over a 13" x 43" frame. Unroll a length of canvas onto a clean surface, such as the floor or a tabletop. Make sure the canvas is primed-side down, and place the frame front-side down on top of the canvas.

 TIP

Keep in mind that unprimed canvas will tighten when primed after the stretching process, which can lead to warping.

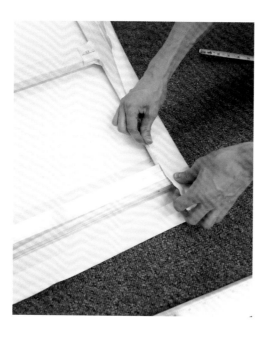

STEP 2

Pull the edge of the canvas over the stretcher bar to determine how much material you'll need to wrap and cover the frame. In this case, 3 inches is a good amount of material. Use the measuring tape and pencil to mark 3 inches of canvas around the entire frame.

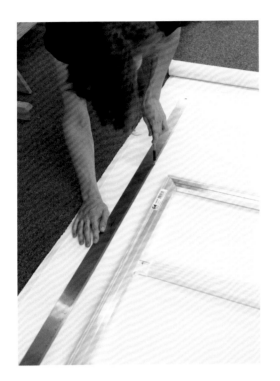

STEP 3

Use your straightedge to pencil in guidelines, and cut the canvas. Note that fabric scissors are sharper than other scissors. They create cleaner cuts and will not dull quickly against the thick threads of canvas.

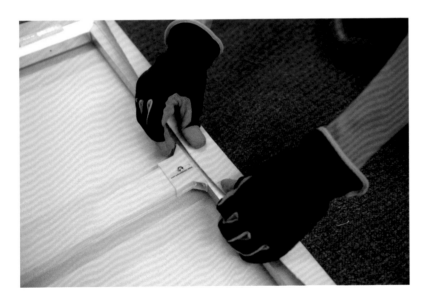

STEP 4

Make sure the frame is centered on your canvas. Then pull and wrap the center edge of canvas up and over the frame. (See point 1 in step 6.) Hold the canvas in place over the edge, and staple it in place.

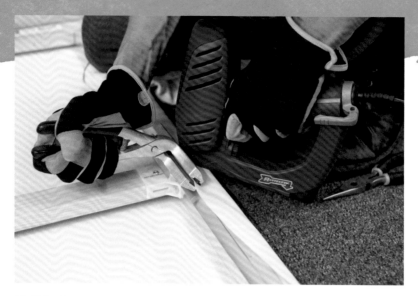

STEP 5

Now move to the opposite point of the canvas (see point 2 in step 6) and use stretcher pliers to pull the canvas taut over the frame. You may need to hold the frame in place by applying weight on it with your knee. If so, place a folded towel between your knee and the frame to keep things cushioned and clean. While pulling the canvas taut with the stretcher pliers, staple the canvas in place.

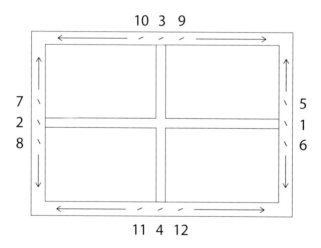

STEP 6

Then use stretcher pliers and the staple gun to secure the first 12 points per the diagram. Once these points are in place, stretch and staple as you move outward from the center of each stretcher bar. As you continue stapling, you may need to remove and re-staple some points to correct the overall tension. Also, check the front of the canvas throughout the process to make sure there are no tears or ripples. To complete the corners, follow the demonstration on the following page.

CREATING A GALLERY-WRAPPED CANVAS CORNER

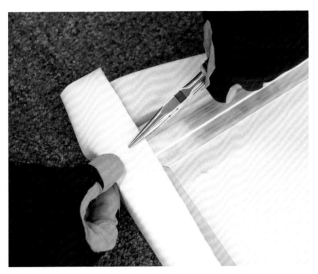

STEP 1

Use the needle-nose pliers to pull the canvas taut over the corner. Staple it in place along the wrapped edge.

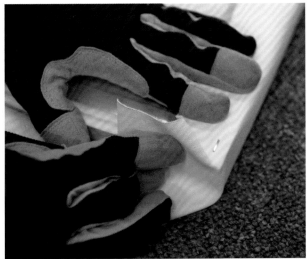

STEP 2

Press the flap of canvas so that it is flush with the bare edge of the frame. Pinch a fold that runs 45 degrees from the corner of the canvas.

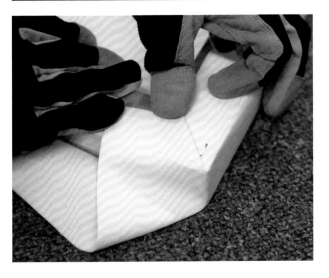

STEP 3

Press down this fold, ensuring that the canvas lays neatly at the corner. Staple in place.

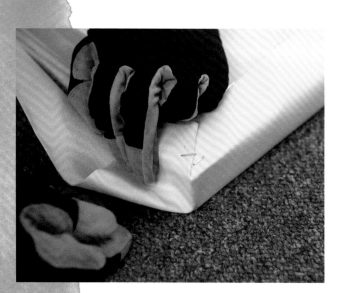

STEP 4

Create another fold by running your fingers along the edge of the frame. This fold, when pulled vertically, should run parallel with the corner's edge.

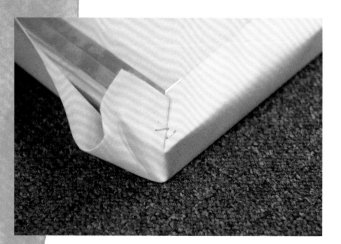

Shown is the fold before being pulled taut onto the frame.

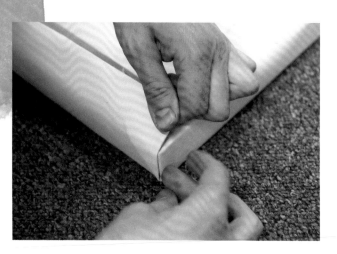

STEP 5

Pull the canvas taut over the corner. Make sure your folds and edges are clean and neat. Remove your gloves if necessary as you make fine adjustments.

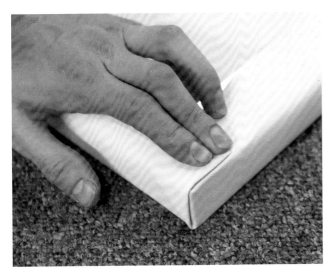

STEP 6

Hold the canvas in place and secure it to the frame with staples.

STEP 7

Shown is a finished example of a gallery-wrapped corner.

CHAPTER 3:

Panels

Wood panels have been used for painting for centuries. While canvas offers more portability, wood panels are still widely used today, along with wood-based composite panels. When prepared properly, panels offer artists a firm, sturdy, and durable support for oil, acrylic, tempera, and encaustic painting.

COMMON HARDWOODS USED FOR PANELS

The best wood to use for panel painting is a hardwood that is not especially vulnerable to rotting or warping. Some of the most common woods used for art panels today are listed below.

	TREE NAME	ORIGIN	QUALITIES
	Mahogany	Semi-evergreen native to the American tropics (some African varietals are sourced for art panels as well)	Reddish-brown, hard, and resistant to rot and insects
	Birch	Broadleaf tree native to North America	Pale in color, lightweight, and affordable
	Maple	Broadleaf tree native to the Northern Hemisphere	Light in color, hard, and affordable
	Basswood (closely related to linden and lime trees of Europe)	Broadleaf tree native to North America	Creamy in color, smooth, lightweight, and affordable

A Brief History of Wood Panel Painting

Wood panels have a long history in Western art. From the fifth century BC through the Middle Ages, locally sourced wood served as a primary painting surface for artists. For example, Leonardo da Vinci—who lived in both Italy and France—worked on poplar, walnut, and oak hardwoods. To prepare the wood for painting, panels were usually treated with steam to remove sticky resins and dried to remove moisture. Then they were coated with sizing, gesso, paint, and finally varnish.

Wood was also the material of choice for Russian and Eastern European religious icon paintings, which are generally dated between the twelfth and nineteenth centuries. Artists applied animal glue over slabs of wood (such as linden or spruce), followed by a layer of linen, gesso, egg tempera paint, and sometimes gold leafing. Many icons have wooden slats inserted across the top and bottom to minimize warping. Still, over time, many have become slightly convex due to the expansion of wood beneath the paint.

Some of the world's oldest and most famous paintings are on panel, from ancient altarpieces to da Vinci's *Mona Lisa* and Jan van Eyck's *Arnolfini Portrait*. Museums care for these works by maintaining consistent levels of humidity. Overall, wood has proven to be an effective and long-lasting painting support, and it remains a popular choice for painters today.

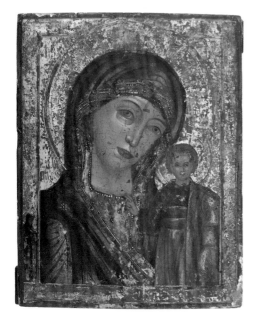

Pictured is an eighteenth-century Christian Orthodox icon believed to be from Lithuania. The thick panel features two wooden slats embedded in the panel to minimize the effects of warping over time. Also visible is a layer of linen fixed over the wood panel, which helped smooth out any defects in the wood.

Prepared Panels

In recent years, manufacturers have started offering a variety of prepared hardboards for specific media—no sanding or priming required. Take a look at some of the surfaces available.

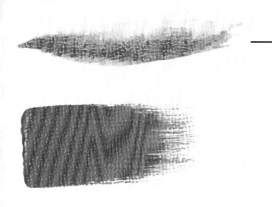

This hardboard (9 mm thick MDF) is primed with acrylic "gesso" and is suitable for acrylic and oil. Its toothy surface simulates canvas texture to give you control over your strokes.

Pastelbord™ is MDF (medium-density fiberboard) primed with kaolin clay ground and textured with fine marble dust granules. This rough, toothy surface is ideal for pastel drawing but can also work with a variety of dry and wet media, from graphite and charcoal to acrylics, oils, and even watercolor. This board is available in white and a small array of midtones.

This gessoed hardboard is an HDF (high-density fiberboard) panel that is ¹/₈" thick and coated with gesso. The surface is compatible with all paints, most notably acrylic and oil. This board is available in white, midtone gray, and umber.

Watercolor panels feature a surface designed to accept wet washes, such as those of watercolor, gouache, and ink. Some textures mimic that of cold-pressed watercolor paper; others have a linen finish coated with gesso that is formulated for water-based media. They come in thin hardboard panels or thicker slabs cradled for depth and extra stability. These boards are generally more expensive than sheets of watercolor paper, but they don't warp, and they make it easy to display finished work.

CHAPTER 4:

Textiles

There are many advantages to textile painting. Fabric is lightweight but tough, so it doesn't tear as easily as paper—and it is far less bulky than panels and canvas. You can also size it to your liking simply by cutting it. The surface might even offer a beautiful grained texture or luster to enhance your artwork. In this chapter, familiarize yourself with the following:

- Types of Fabric
- Paints & Dyes
- Batik
- Silk Painting
- Additional Non-rigid Surfaces

Types of Fabric

Fabric is made up of woven fibers that create sheets of pliable material. Nearly any type of fabric can be used as a painting surface, from 100-percent cotton and silk to polyester and synthetic blends. Below are tips to keep in mind as you select your surface.

- Choose a weave that suits your style. Large weaves yield broken, textured strokes of paint, whereas tight weaves yield smooth strokes capable of fine detail.

- Make sure that your medium is compatible with the fibers of your weave. Paint and dye manufacturers usually specify compatibility in charts near product displays.

- The paint you choose must dry to a flexible finish to avoid any cracking that could happen on pliable material.

- It's best to pre-wash, dry, iron (if compatible), and stretch your fabric to prevent shrinking or warping after you've applied paint.

- Take into account the base color of your fabric, as this will tone your paint or dye. It is more difficult to achieve light, bright colors when working on dark textiles.

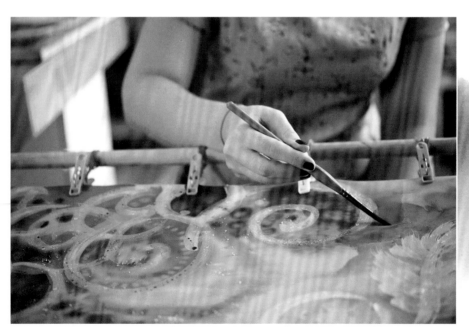

It's best to keep your fabric pulled taut as you paint, which will keep it from moving and crinkling under your brush. You can suspend it between a frame using clothespins or clamps, or you can wrap and secure it around a board.

Paints & Dyes

The most important quality of fabric paint is its flexibility. You can purchase paints formulated specifically for use on textiles, or you can alter acrylic paint with an additive to make it dry to a more flexible finish, allowing it to bend with the material's surface. This additive is often called "textile medium" or "fabric medium."

Unlike paints, which sit on the surface of the fibers like a film, dyes react chemically and bond with the fibers. They do not change the overall feel of the fabric. In general, dyes have a more fluid appearance and can produce soft edges and gradations, whereas paints can yield sharper strokes.

TIP

In addition to traditional brushes, you can use sponges, stamps, and rollers to apply paint to fabric. You can also use stencils as guides for patternwork.

Fabric paint is a thin, acrylic-based craft paint available at art stores. Mix these paints on a simple plastic or aluminum palette to create new variations of color, and thin them with textile and fabric medium.

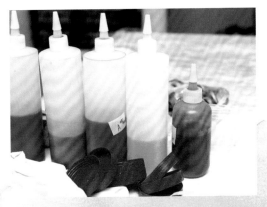

Dyes are very thin, colored fluids that artists prepare and disperse from nozzled bottles. Dyes call for safety precautions, such as masks and gloves. Be sure to read the guidelines before you begin.

Folk Art-Inspired Flower on Cotton

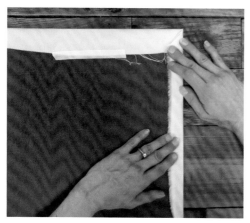

Begin by wrapping your pre-washed and dried fabric around a board.

If you want to sketch in guidelines for your design, use a chalk pencil. When working on dark fabrics, use white. When working with thin fabric, you can also slip a sketch between your board and fabric for tracing.

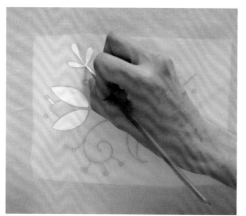

Thin the fabric paint with medium so that it flows smoothly when you stroke. Vary the line width of your strokes for interest, and remember that imperfections will give your design a charming hand-painted quality.

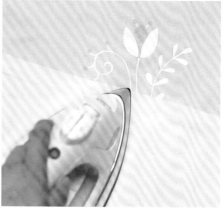

Remove wrinkles and set the fabric paint by using a pressing cloth between the surface of the painting and a hot iron. (The iron should be set to the appropriate temperature for the fabric.) You can also iron the back of the painted fabric. Setting with heat will allow you to wash the fabric without disturbing the paint.

Batik

Originating from the island of Java in Indonesia, batik is an Asian art form that involves creating designs on fabrics using dyes and wax resists. The method works with a variety of fabrics, from cotton to silk. Batik is used to create works of art as well as decorative cloth for garments.

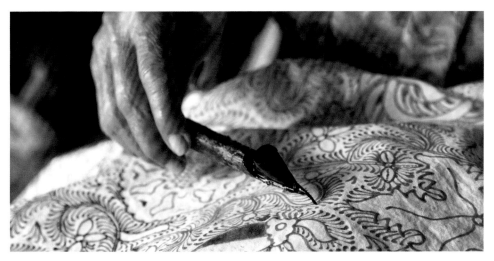

The most important tool in batik is the tjanting, which holds melted wax (usually beeswax and paraffin) and disperses it in dots and thin lines. The fabric is then dyed, preserving the original color of fabric beneath the wax. Artists might then choose to add more wax and dye again for multiple colors. Ultimately, artists boil out the remaining wax once the design is complete.

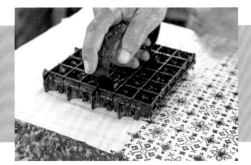

Tjaps are another tool often used by batik artists. These copper tools can stamp wax (and even paint) onto fabric to create intricate patterns across lengths of material.

Traditional batik generally uses floral motifs, but you can experiment with the technique to create modern designs and even scenes.

Silk Painting

Silk is made from woven fibers produced by silkworms or moth caterpillars, creating fabric that is soft but strong and with a unique luster. Painting on silk is an Asian art form that dates to before 100 BC. The process involves applying pigments to silk in concert with gutta—a water-based gum that acts as a resist, stopping the flow of pigment across the silk.

PAINTS & DYES FOR SILK

Silk can be colored with paints or dyes, but both need to be set with either steam or a hot iron to make the colors permanent and washable. Silk paints are water-based, nontoxic, easy-to-use colors that you dilute with water, and they can be heat-set with a dry iron. They are generally less expensive than silk dyes, and they are a little easier to work with because they mix and clean up easily with water. However, dyes yield richer colors.

Silk dyes are professional chemical colors that you thin with a solution of water and rubbing alcohol. They are transparent and blend easily, and they flow beautifully when applied to the silk. The most concentrated types of dyes must be steam-set, but some brands can be set with a liquid fixative or heat-set with an iron.

TIP

Dyes and resists are strong chemicals, so take some precautions when working with them. Always read the directions before using any product, especially oil-based gutta resists.

TYPES OF SILK

Silk comes in a variety of weights (5mm, 8mm, and higher) and types of weave, and each type varies in feel and in the way that it reacts to colors. China silk (also called "habotai") is the best type for beginning projects. It's economical and has a smooth surface and an even weave, so the colors flow evenly. Crepe de Chine is a slightly heavier silk used for scarves and other articles of clothing. Silk charmeuse is also heavier, with a very soft feel and a beautiful drape. Chiffon, georgette, and organza are translucent silks that cause the dye colors to appear light and delicate. Twill, jacquard, and dupioni are textured silks with a subtle pattern on the surface.

You must always stretch the silk on a frame before painting. Stretching makes the silk taut so that the colors won't puddle, and the frame holds the silk away from your work surface.

Sketch your design onto the silk using a washable pencil; then trace over the lines with clear gutta. Enclose all the shapes so that the dyes won't bleed into the wrong area.

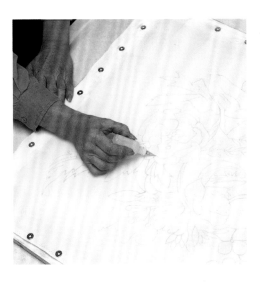

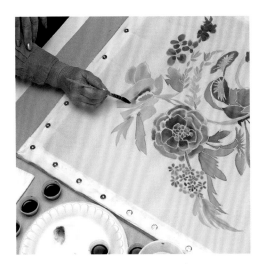

Begin painting by first wetting the area with water; then carefully apply a little color from one side of the area to the other, blending as you go. Blot off any excess water with a dry cotton swab. To get a graduated light-to-dark effect, wet the silk and apply a pastel (diluted) color. While the color is still slightly damp, add a darker shade of the same color along the edge, letting the two shades blend together. Repeat with an even darker shade if desired. Shown here, gradations of color create dimension in the flower petals.

47

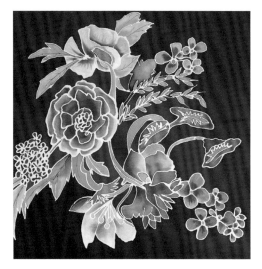

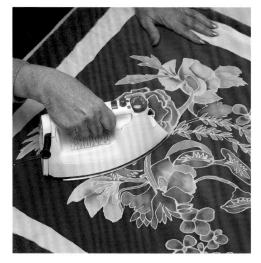

When the color is completely dry, remove the silk from the frame. You can either remove the gutta now, or wait until after you have set the colors.

Steam-set the dyes following the dye manufacturer's instructions, rinse with water and mild soap, and blot out the moisture by rolling the silk in a towel. Use a dry iron to smooth over the silk and permanently set the colors.

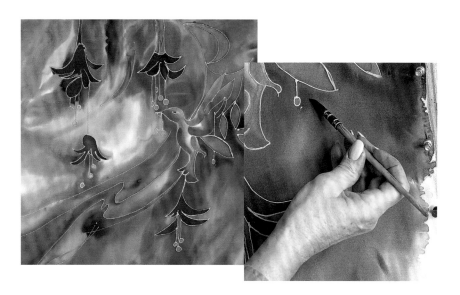

For this piece, Christine Mariotti used gutta as a design element rather than as a resist. She painted the background first and then drew the outlines of the bird and flowers with gold gutta. The stronger colors in the fuchsias and hummingbird make them stand out against the blended pastel background.

Additional Non-rigid Surfaces

Because acrylics are water-based, flexible, and durable, they are a top choice of paint for working on non-rigid surfaces such as animal hides and synthetic fabrics. To make any acrylic paint even more suitable for these surfaces, remember that you can add fabric or textile medium to reduce the chance of cracking and chipping. Below are a few non-rigid surfaces that can serve as unconventional supports for works of art. Keep in mind that these surfaces must be clean, uncoated, and dry in order to properly accept paint.

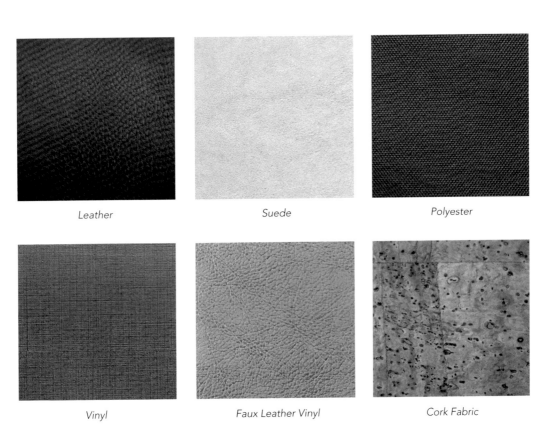

| Leather | Suede | Polyester |
| Vinyl | Faux Leather Vinyl | Cork Fabric |

TIP

To keep non-rigid material steady and flat while painting, you can either wrap it around a board or suspend it in a stretcher, such as a silk stretcher frame. A stretcher is a great way to achieve a taut surface and avoid wrinkles.

CHAPTER 5:
Alternative Surfaces

Aside from traditional paper, canvas, and panels, you can create art on a variety of surfaces, including natural wood, metal, stone, glass, ceramic, and Mylar™. Alternative supports often need to be cleaned and prepped for paint. Following are some tips for experimenting with these unusual supports, as well as examples of the beautiful results you can achieve.

Natural Wood

Painting on natural wood is similar to painting on raw wood panel; you must seal it to prevent impurities from leaching into your paint and to keep moisture from rotting the wood. However, you don't have to prime it with ground or white gesso before painting. Some artists enjoy painting on the light, warm tones and subtly ringed surface of natural wood. In this silhouette demonstration, you can see how simple it is to prepare a raw slice of tree trunk for acrylic or oil paint.

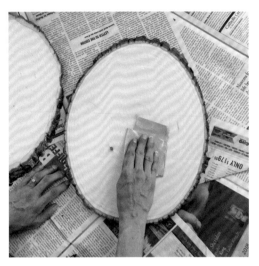

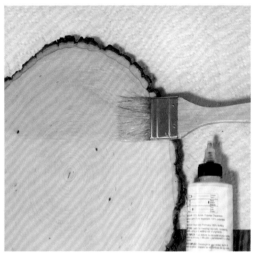

STEP 1

Using sandpaper, smooth out any surface irregularities on the wood that might interfere with your brushstrokes. Then use a large brush (such as a house brush) to remove bits of wood and dust, followed by a damp rag that won't leave behind lint. Allow the wood to dry.

STEP 2

To seal the wood, apply a couple coats of a clear polymer emulsion (acrylic based) or PVA glue (latex based). These milky substances will dry to a clear finish, allowing the natural grains of the wood to show unaffected. You can use any large brush to apply the seal—a house or chip brush are great options.

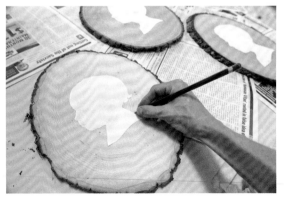

STEP 3

If desired, sketch your subject before applying any paint. For this demonstration, you can cut silhouettes from paper using a craft knife. Then use a non-staining watercolor pencil (such as raw sienna) to trace onto the wood. (This pencil can be wiped away from the silhouette edges using a damp, lint-free cloth, once the paint is dry.)

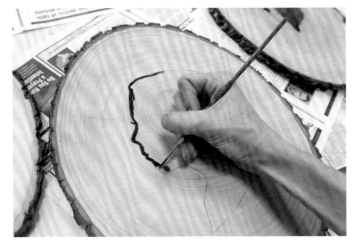

STEP 4

Use a small round or liner brush and paint that has been thinned a bit to follow the silhouette lines faithfully.

STEP 5

Once the more delicate edges are in place, fill in the bulk of the silhouette with a larger brush and smooth strokes. Once dry, apply your chosen varnish to protect the painting.

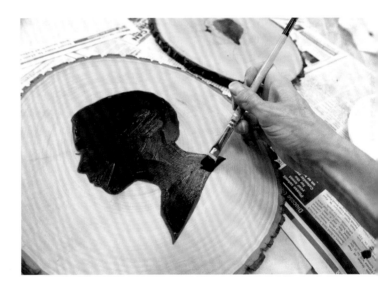

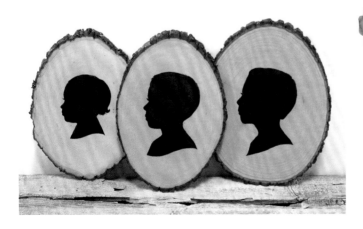

TIP

You can also stain or bleach wood to change its tone before using it as a painting surface. Simply apply the treatment—and allow the wood to fully dry—before you apply the seal.

Metal

Metal is a very hardy, archival surface that can give your paintings a unique glow. Sheet metal is available from various sources: online, scrap metal yards, or even some art-supply stores. Steel, aluminum, and copper are good options; however, if you use steel, be sure to remove any rust before cleaning the surface and applying paint. Below are tips for preparing a metal surface for painting:

- Use oil or vinegar to clean the surface well and remove any oil or dirt.
- Rough up or scratch the surface to produce a tooth that will hold your medium. Use sandpaper, a wire brush, or a steel sponge pad.
- Consider a clear seal or primer, which will create a barrier between the metal and paint and help prevent rust. Good choices for this include clear acrylic dispersion medium or PVA dispersion.

Copper is a reflective metal that boasts bright orange, red, and cream tones, as seen in this artwork by Candice Bohannon. The luminous quality of the copper seems to come through the paint, offering a great background for flesh and portrait paintings. Artists usually prepare copper by roughing up the surface with fine sandpaper and cleaning it with rubbing alcohol or acetone. Some artists also rub down the surface with raw garlic to further etch (see page 56).

WARNING

Work in a well-ventilated area and wear a mask, goggles, and gloves while sanding or scoring metal.

PREPARING ALUMINUM FOR PAINT

Acrylic paint is the best choice for painting on aluminum sheet, as it is most likely to flex with the surface.

STEP 1 Wearing a mask, goggles, and rubber or latex gloves, use a wire brush or pad to score the surface of your aluminum sheet, working in small, circular movements.

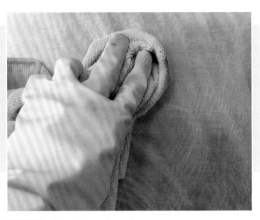

STEP 2 Clean the aluminum to remove all dirt and oil, using a soft cloth and rubbing alcohol.

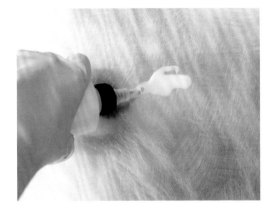

STEP 3 Some artists paint directly on the aluminum, but you can also apply a clear layer of seal using acrylic gel medium, followed by a clear acrylic dispersion primer. Use a soft-haired brush or a foam brush to spread the medium or primer evenly over the surface in parallel strokes.

STEP 4 Your surface is ready to paint. Apply the paint using soft-haired brushes to avoid large streaks left behind by coarse bristles.

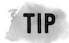

TIP Limit the amount of water added to acrylic paint when working with metal. Thinned strokes and washes can appear streaky and irregular.

COPPER WITH CANDICE BOHANNON

In this demonstration, you'll learn how artist Candice Bohannon prepares and applies oil paints to copper plate.

Because copper plate is flexible, you'll want to glue it (PVA glue works well) to a hard substrate, such as MDF board. Then seal the substrate to prevent moisture from warping it. Similar to prepping aluminum for paint, you'll want to sand or use a steel brush to rough up the copper surface and provide tooth for the paint; then wash and wipe it clean. To further etch the surface, rub a raw piece of cut garlic over the copper. This allows for a chemical bond to form between the copper and the lead in your white primer or paint.

TIP Use gloves as you work to prevent the oils of your skin from transferring to the copper surface. If you're working without a primer, be sure to cover all areas of copper to prevent it from turning green over time due to exposure to the air.

Place your mounted copper plate on an easel, and you're ready to begin! You can choose to apply paint directly on the copper or add a primer first.

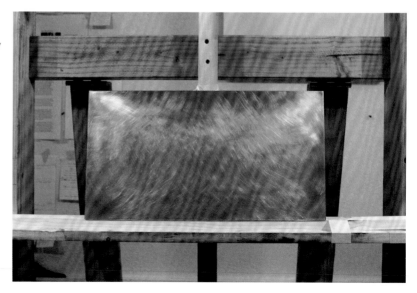

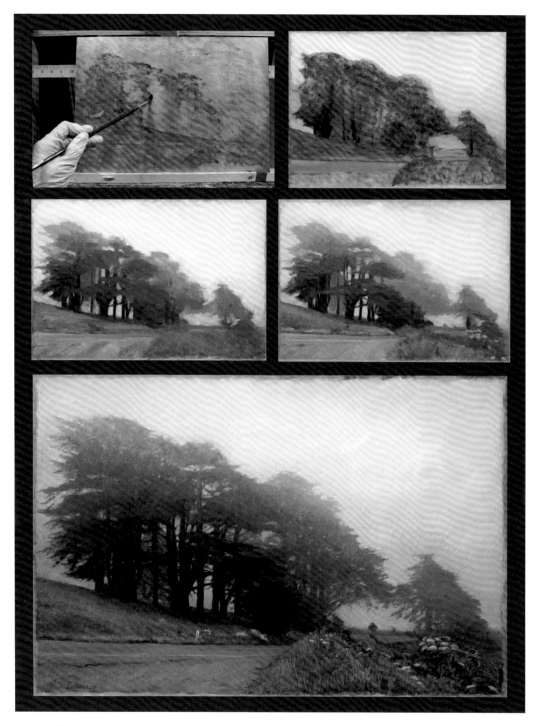

Candice blocks in the darkest shapes of her scene with thinned oil paints, building up layers with thicker, more opaque layers to create this foggy landscape scene.

STONE

Stone is the oldest painting surface used by man. Cave and rock paintings offer glimpses into human life that stretch back more than 10,000 years, when charcoal and pigments were used to depict animals, weapons, and humans. Today, stone is still a surface of choice for many artists. It's heavy and can be a challenge to transport and display, but its irregular textures, striations, speckles, and edges give it a unique earthy quality that makes it all worthwhile.

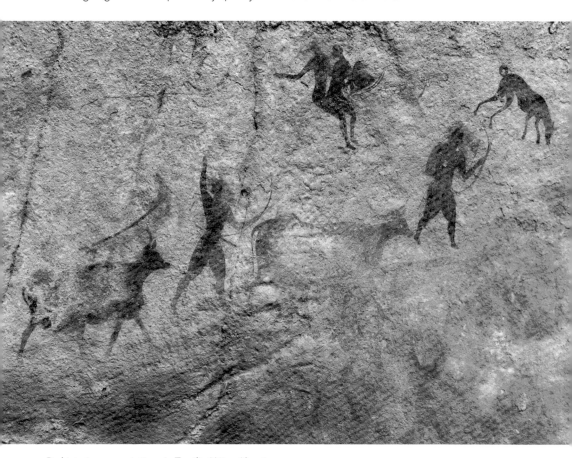

Prehistoric cave paintings in Tassili n'Ajjer, Algeria.

PREPARING A STONE SURFACE

Stone is a viable surface for both acrylic and oil paints. Prepare your rocks by thoroughly removing dirt and oil using a brush, soap, and warm water. Then apply an alkyd resin (such as Liquin™), a clear acrylic dispersion ground, or a stone sealant before painting. This will protect the rock from absorbing moisture and discoloring over time, and it will give the paint something to grab onto. To protect the paint, always finish by sealing with varnish.

TYPES OF STONE

Many artists like to paint on rocks and stones they discover in nature. However, you can buy slabs of specific types of stone (and often discounted scraps) online and at building-supply stores. The chart below features some of the most common types of stone used for painting.

Stone	Qualities	Appearance
Granite	Hard and chip-resistant with veining and flecks. Colors range from grays and creams to oranges, blues, and greens.	
Marble	Slightly softer than granite. Features light, marbled veining. Generally white, gray, or pink in color.	
Slate	Fine-grained stone that is generally gray with subtle variations in color.	
Soapstone	Talc-based rock with a soft, smooth feel. A favorite stone for carving. Colors range from gray tones to browns. Nonporous and resistant to changes from acids.	
Sandstone	Coarse rock with a variable density. Features visible layers and undulating striations. Generally warm in color, it can be any combination of orange, red, yellow, cream, brown, or even	
Travertine	Soft but dense stone. Generally cream, peach, pink, white, or silver.	

PAINTING ON STONE WITH SUSAN VON BORSTEL

Artist Susan von Borstel uses oil paint on stone to create stunning works of art that blend natural patterns with representational painting. First she looks at the patterns on a slab of stone to see what they resemble, and then she slowly brings out her subject. She compares the process of painting on stone to working in a photo darkroom, watching as the subject emerges. Susan tries to leave as much of the natural pattern as possible, noting that the less paint she applies to the stone, the more it appeals to viewers.

Susan uses a hard sanding block to smooth any broken edges of her stones, such as this granite slab. She also cleans the faces of her stones and then seals them with Liquin before applying any paint.

This slab of granite features interesting areas of contrast that lend themselves well to the subject. See how Susan used the naturally occurring shapes to form the horse and background trees, in particular.

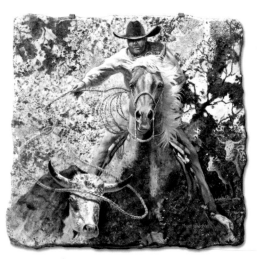

Nice Catch by Susan von Borstel. Oil on granite.

Above is a peek at the quartz surface used for Light and Magic *at right. The soft, light marbling is an elegant base for depicting creamy horse coats and manes.*

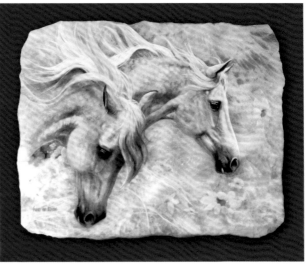

Light and Magic *by Susan von Borstel. Oil on quartz.*

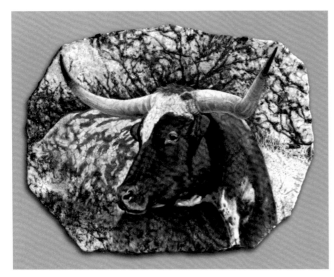

Goodlookin' *by Susan von Borstel. Oil on granite.*

Ceramic

Ceramic is a rocklike material made of clay hardened by heat. Some artists use ceramic plates, vases, bowls, or drinkware as a surface for creating colorful patterns, designs, and even scenes or portraits. Ceramic is heavy and fragile and requires an investment in time and materials, but it can serve as a base for dramatic pieces that provide function as well as form.

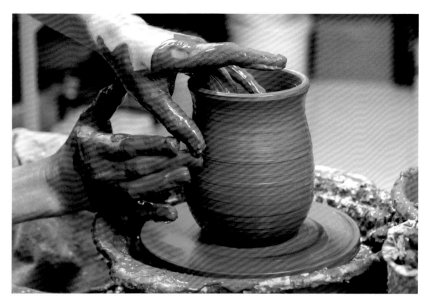

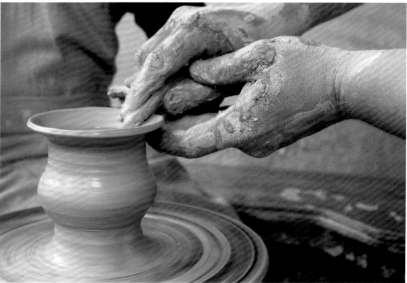

The main types of clay used by ceramic artists include earthenware (top), stoneware, firing clay, and kaolin clay (which makes porcelain; bottom). Each type of clay has its own color ranges and requires different firing temperatures.

THE FIRING PROCESS

Typically, a ceramic piece is bisque fired after the artist completes the clay form. Bisque firing involves baking the pieces at a low temperature (depending upon the clay) to remove moisture, organic impurities, and air bubbles. Firing takes place in a kiln, which is a chamber or oven that holds heat. Many kilns use actual fire as a source of heat, but electric kilns (which allow for greater control over temperature) are becoming more common in the field of ceramics.

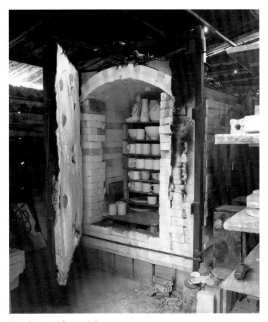

Traditional firing kiln

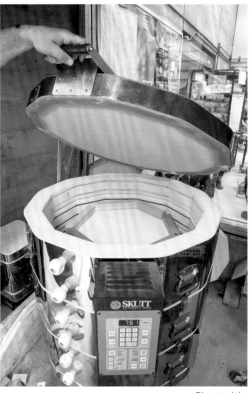

Electric kiln

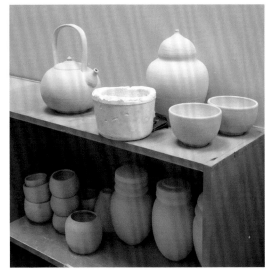

Shown are examples of bisque-fired pieces awaiting the glazing process. Once glazed, the pieces will move on to the final round(s) of firing, which will give color and a hard, glass-like finish to the pieces.

GLAZES & UNDERGLAZES

Although some artists use acrylic paints formulated for use on dry ceramic, most ceramic artists create their art using glazes and underglazes rather than paints. Most glazes are liquid mixtures of silica (which melts into glass), alumina (a stabilizer that keeps the glaze in place), flux (such as sodium, which helps melt the glass), and colorant (such as copper oxide, which interacts with the firing process to create color). Underglazes are similar to glazes but contain slip (or liquid clay), allowing them to shrink with the piece during the firing process and stay in place for more detailed design work.

Prior to firing, liquid glazes and underglazes have the appearance of opaque, chalky paint. They yield a variety of colors with a range of qualities to consider, such as gloss, matte, satin, opalescent, and mottled finishes.

 TIP Ceramic artists rely on a pyrometric cone system (which gauges heat) to mature their glazes and underglazes. Cone numbers are associated with temperatures; for example, a cone 6 glaze matures at 2232 degrees Fahrenheit. Always keep in mind that each glaze and underglaze calls for its own firing temperature.

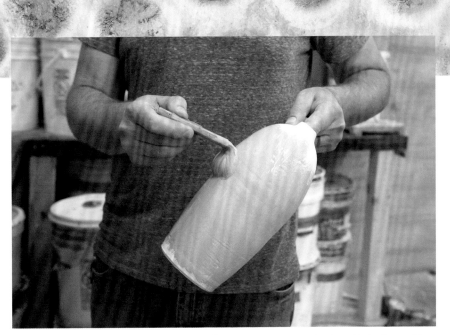

Large, soft brushes (such as hake) are great for coating a piece with glaze. Typically, you'll want to apply six brushed coats of glaze (or two dipped coats) before firing.

Because glazes can look so different before firing, it's a good idea to store or display samples of each finished glaze.

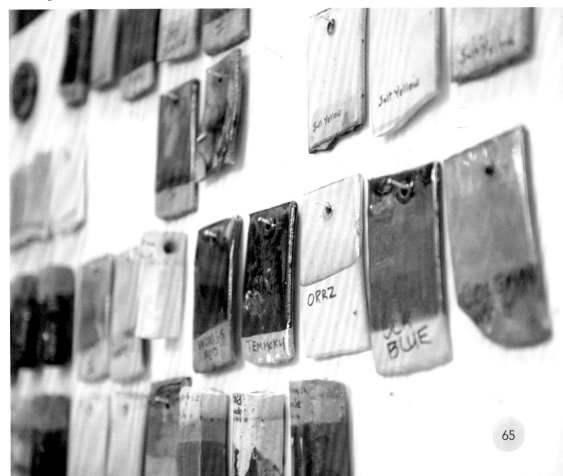

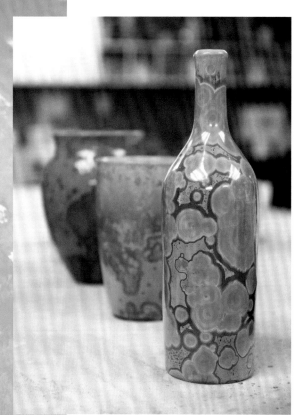

Crystalline glazes create unique and unexpected shapes. These crystals are the result of additives such as zinc oxide or titanium dioxide (referred to as "seeds"), which create interesting formations at specific temperatures.

Raku—a Japanese method of firing—involves removing the piece from the kiln while it is still hot and glowing. This method calls for a special Raku kiln and additional tools, such as gloves and tongs. It can result in metallic glazes with unique markings from the smoke and flames.

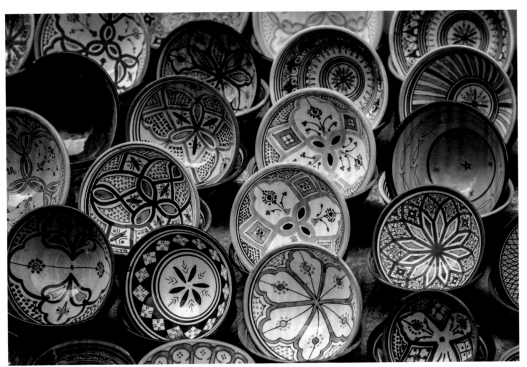

Moroccan-style pottery and tiles showcase detailed designs made with fine brushes and underglazes that are fired at low temperatures, which keeps the lines and colors from blending into one another. Underglazes that bake to a dry finish are typically coated with a clear glaze for a finished, glossy appearance.

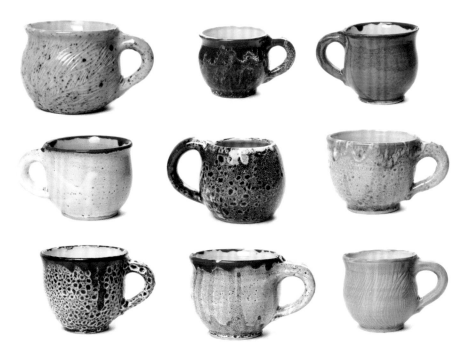

The process of glazing and firing ceramics involves an element of surprise. You never know exactly how a piece will turn out! Variations in texture and color are inevitable, making each piece a unique treasure.

Glass

Glass can serve as a transparent painting surface for artists who like working with light, as well as those who enjoy painting on functional objects, such as drinkware, plates, and candlesticks. Although it's fragile and challenging to transport, glass is readily available and allows for luminous strokes of bright, rich colors.

TIP

When working with raw edges of glass, cover the sharp edges and corners with artist's tape to reduce the risk of getting cut. You might also want to invest in protective gloves when moving sheets.

PREPARING THE GLASS

Clean the glass with rubbing alcohol and a cotton ball. While cleaning the glass, wear latex gloves to prevent any fingerprints from making their way to the surface. The oil from your skin will prevent the paint from adhering properly. (You may want to paint while wearing latex gloves too!) Before you apply any paint to the glass, be sure it's dry and streak free.

GLASS PAINTS

Almost all glass painters use acrylics formulated specifically for working on glass or multiple surfaces. These paints often come in squeeze bottles and are available in a variety of sheens and finishes, including glossy, chalky, or frosty. After application, glass paints need to cure (or fully harden) for an extended amount of time. You can accelerate this process by baking your painted glass. Refer to your paint manufacturer's instructions for specifics.

Satin

Metallic

Gloss

Chalk

Frost

Glitter

TIP

Synthetic, soft-haired brushes work well with these acrylic paints. The softer the hairs, the less textured your strokes will be, and the more even your paint coverage. Some artists enjoy the dramatic streaks you can achieve with bristle brushes. Try both!

69

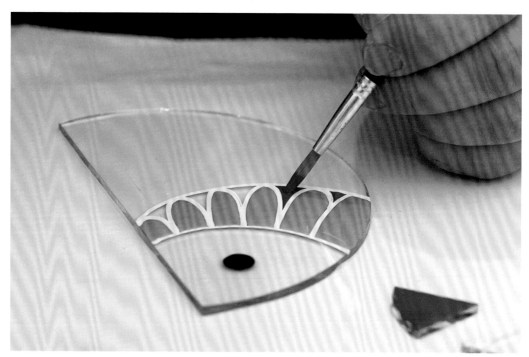

Remember that you're not limited to squares or rectangles! Uniquely shaped glass pieces and scraps can serve as a base for whimsical paintings and mixed-media works.

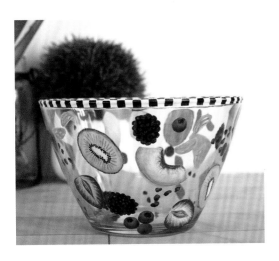

Painted Fruit Bowl designed by Gigi Wright-Shattler. Courtesy of DecoArt®.

Bring life to a glass serving bowl with brightly colored fruits. You can blend the acrylics to create realistic gradations, such as the orange-to-buttermilk blend within the peach slice. Detail your pieces with small round and liner brushes.

Modern Impressionist Glass Set designed by PLA Schneider. Courtesy of DecoArt®.

Use a medium round brush to apply short, horizontal strokes of varying colors across the surface of the glass, keeping like colors near each other. These loose, rhythmic strokes echo the feel of impressionist paintings, such as those of Claude Monet.

Faux Pressed Leaves designed by Felicity Greiner. Courtesy of DecoArt®.

Use small flat and round brushes to create delicate leaf shapes on your glass (or even plexiglass). Use variations of greens, yellows, and browns to create highlights, shadows, stems, and veins. These paintings create the appearance of pressed and preserved leaves, but they'll never turn brown!

Mylar™

Mylar, a polyester film that is acid-free and archival is available from Grafix®. Grafix makes a variety of plastic "drafting" films, available in pads, rolls, and packs. It looks similar to tracing paper, but it's thicker and doesn't tear, rip, or yellow with age. There are several types of Dura-Lar™ film available from Grafix, including the following:

- Clear Dura-Lar is a great surface for permanent inks and markers.
- Matte Dura-Lar has a matte translucent drawing surface on both sides. It will accept lead, ink, charcoal, paint, and colored pencil.
- Wet Media Dura-Lar is specially coated on both sides to accept water-based media, markers, and inks without beading or running.
- Metallized Dura-Lar has a thin coating of aluminum.

Shown here is matte double-frosted Mylar. The surface has a "frosted" semi-opaque texture on both sides, which allows for layering of colored pencil. The final appearance looks more like a painting than a colored pencil drawing. The microscopic tooth of the paper allows for fine details.

Image courtesy of Grafix®.

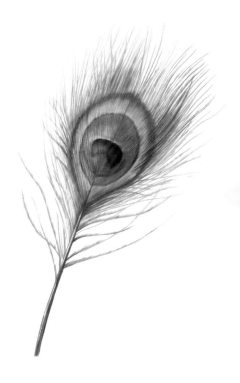

FEATHER IN COLORED PENCIL

Artist Mindy Lighthipe used colored pencils to draw this beautiful peacock feather. She worked on both sides of the double-frosted Mylar to develop layers of color and dimension.

ARTICHOKE IN PEN & INK

Double-frosted Mylar is also a great surface for pen and ink. Mindy Lighthipe illustrated this artichoke with a dip pen and ink.

CHAPTER 6:

Selecting & Preparing Your Surface

The surface, or support, that you choose for your drawing or painting helps determine the quality of your work—from texture, brightness, and color to longevity. Before you select a support, the following are helpful questions to ask:

- Is the support compatible with your medium?
- How will the brightness and color of your support affect the medium?
- How will the texture relate to your subject?
- How will the support help you communicate your artistic message?
- Is the support durable enough for the work's purpose?
- Will the support help your work stand the test of time?

Choosing Your Support

Paper, canvas, and wood panels are the most common drawing and painting supports, but don't feel pressured into a traditional approach. Artists throughout the centuries have explored (and found success with) a variety of surfaces, including animal skins and sheet metal. The more you understand why and how artists work with particular surfaces, the more likely you are to find success with your own artistic experiments and decisions.

Graphite	Smooth or medium-textured drawing paper
Colored Pencil	Fine-tooth drawing paper, Bristol board
Charcoal	Laid drawing paper, rough drawing paper
Conté Crayon	Fine-tooth drawing paper, rough drawing paper
Pastel	Fine-tooth drawing paper, laid drawing paper, rough drawing paper
Marker	Marker paper
Pen & Ink	Smooth drawing paper, Bristol board, marker paper
Watercolor	Watercolor paper, rice paper
Gouache	Watercolor paper, illustration board
Acrylic	Watercolor paper, canvas paper, canvas panel, pre-primed and stretched canvas, wood panel
Oil	Canvas paper, canvas panel, pre-primed and stretched canvas, wood panel

MEDIUM MATCHUP

Here is a quick key for beginning artists who want to know the most common supports used for the most common media.

When selecting paper for a finished drawing, note the following:

- Test your paper while working on your chosen surface. This will help you assess how the medium, paper, and surface work together.
- Beware of working on uncoated or soft wood, which scores easily beneath harder mediums such as graphite.
- To reduce the risk of creasing the sheet or damaging its edges, work on a surface that is larger than your paper.
- Don't work on a textured or seamed surface, as it will affect the flow of your strokes.
- You may prefer to draw on a small stack of papers for a soft, cushioned feel.
- Before laying down your paper on a drawing surface, use a soft drafting brush to wipe away any dirt or old eraser crumbs. Make sure the surface is free of oil and moisture.

A simple wood-based composite board (such as MDF) and drawing paper secured with artist tape make a great portable drawing surface.

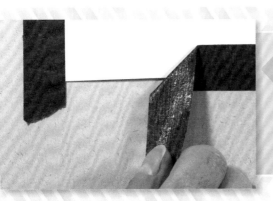

TIP

To reduce the risk of tearing, pull the tape away from the paper at a 90-degree angle.

GRAPHITE

Graphite is versatile and works well on a number of paper types. Below are graphite spheres (created with HB pencil and minimal blending) on a sampling of common surfaces, including toned kraft paper, smooth drawing paper, medium drawing paper, and cold-pressed drawing paper. Note the differences in value and stroke quality.

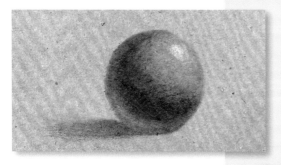

Graphite over rough, brown kraft paper creates a dark, dramatic feel. I added extra dimension by applying white crayon over the highlight.

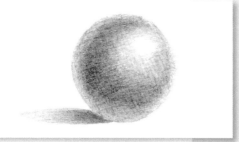

Smooth drawing paper offers plenty of control over graphite and allows you to build up subtle layers of crosshatching. Because the paper has little to no tooth, it is not easy to achieve dark values.

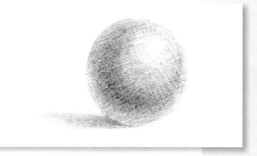

Medium drawing paper is often considered the most versatile surface for graphite. It has enough tooth to hold darker strokes, but it also allows for smooth blends.

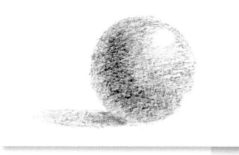

Cold-pressed paper is a rougher, more inconsistent surface for graphite. It's best to work on this textured paper at larger scales, as it is difficult to control the quality of smaller strokes.

PENCIL HARDNESS

Keep in mind that the hardness of the pencil affects the quality of line and tone on the paper. Pictured here are gradations of 8B, 4B, HB, and 4H on medium drawing paper, allowing you to see the differences in stroke quality and darkness.

8B 4B HB 4H

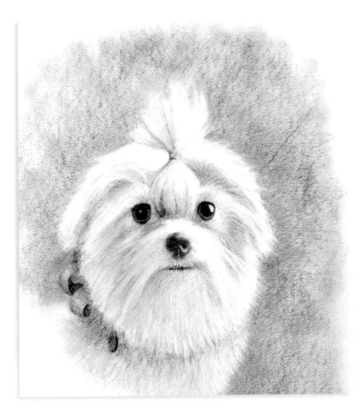

In this dog portrait, the dark accent strokes were made with a 4B pencil, and the richest shading was done with an 8B pencil.

PEN & INK

Each pen delivers ink to the paper differently; the pressure, angle, speed, and stroke direction determine the length, width, intensity, and character of your strokes. Whether you are working with traditional dip pens or markers, most pens work best on smooth drawing papers, but cold-pressed watercolor paper also works well if you're incorporating ink washes or working with ballpoint pens.

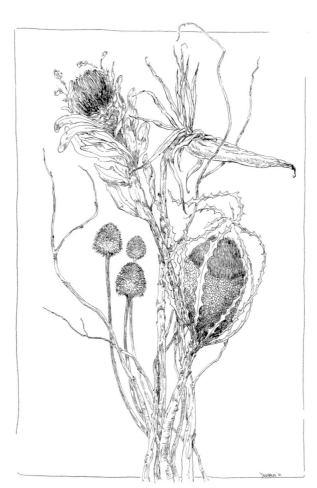

Artwork by Jim Dowdalls

Smooth drawing surfaces are ideal for pen and ink, especially for illustrations that call for precise rendering.

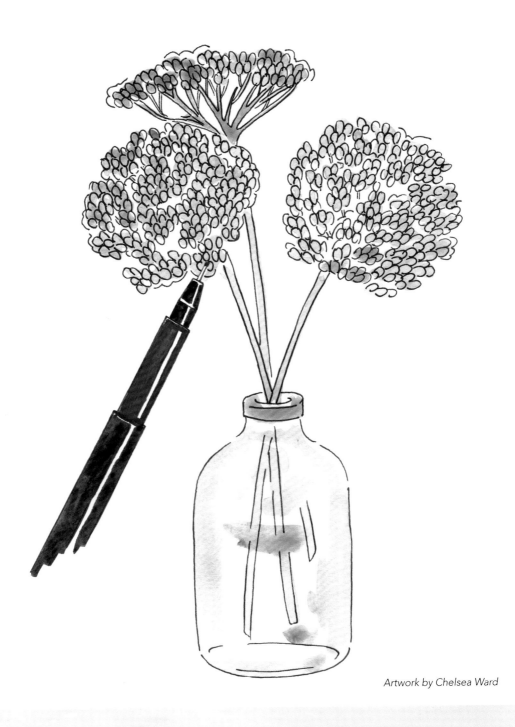

Artwork by Chelsea Ward

Ink drawings don't necessarily need to be black-and-white. You can work with colored ink or combine ink and watercolor washes to create colorful works of art like this floral illustration.

CHARCOAL

Charcoal is a dramatic alternative to graphite. It can also create subtle, velvety blends and fine detail. This medium works best on rougher paper surfaces with plenty of tooth. Because charcoal is dusty and dry by nature, it lifts easily and can sometimes be blown off the paper or canvas. Use fixative on your finished drawings to ensure that they last.

RECOMMENDED SUPPORTS

- Newsprint
- Rough drawing paper
- Fine-toothed drawing
- Cold-pressed paper
- Laid drawing paper
- Toned paper (with tooth)

Note: Some manufacturers offer "charcoal paper." This surface generally has a laid finish or fine tooth.

A

B

A) Charcoal produces bold, expressive strokes and is easy to blend, making it ideal for quick life-drawing sketches and gesture drawings.

B) Many artists opt to draw on toned paper. The value of the paper acts as a middle value to which you can add shadows and highlights. Because a middle value is already in place, you can develop forms quickly and boldly. In the above piece, I used charcoal and white pencil on gray toned paper, emphasizing the dramatic portrait lighting.

CONTÉ CRAYON

Conté crayons, or Conté sticks, deliver rich, textured strokes that glide easily across the paper. You can use them to produce tight lines, broad strokes, and lightly blended areas of tone.

RECOMMENDED SUPPORTS

- Medium drawing paper
- Rough drawing paper
- Fine-toothed drawing paper
- Cold-pressed paper
- Toned paper

Artists often pair Conté crayons with toned paper, such as gray, cream, or light brown. If using a gray support, artists work with black and white Conté; if using a cream or light brown support, artists generally work with sanguine and white Conté.

COLORED PENCIL

Colored pencil works well on multiple supports, from smooth and rough to toned surfaces. Many artists find it easiest to work on a surface with at least a slight tooth.

RECOMMENDED SUPPORTS

- Smooth drawing paper
- Medium drawing paper
- Fine-toothed drawing paper
- Bristol board
- Toned paper

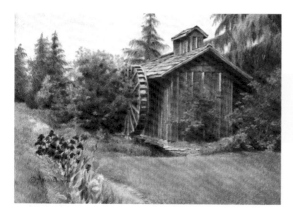

In this example, artist Pat Averill uses subtle, muted colors and a light touch to communicate serenity.

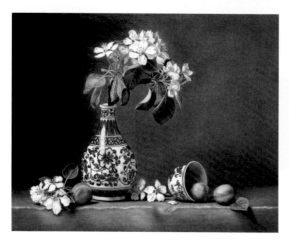

Artist Cynthia Knox uses colored pencils to create a classic and photorealistic still life, imitating the luminous quality of oils.

HARD & SOFT PASTELS

Paper is an important part of pastel artwork. Whether you're using hard or soft pastels, choose paper that has a textured surface so the raised areas catch and hold the pastel. You might also opt for toned paper, which enriches the colors with a subtle, uniting hue and prevents distracting bits of white paper from showing through.

RECOMMENDED SUPPORTS

- Rough drawing paper
- Fine-toothed drawing paper
- Sanded pastel paper
- Cold-pressed paper
- Laid drawing paper
- Toned paper (with tooth)

WORKING ON TONED PAPER

Many pastel artists choose to work on toned paper, which results in richer colors and unifies the hues of the work. In this apple sketch, the orange of the paper provides a warm base for building up strokes.

TIP

The powdery nature of soft pastel makes your finished pieces vulnerable to smudging. Artists often use spray fixative to seal and protect their finished work.

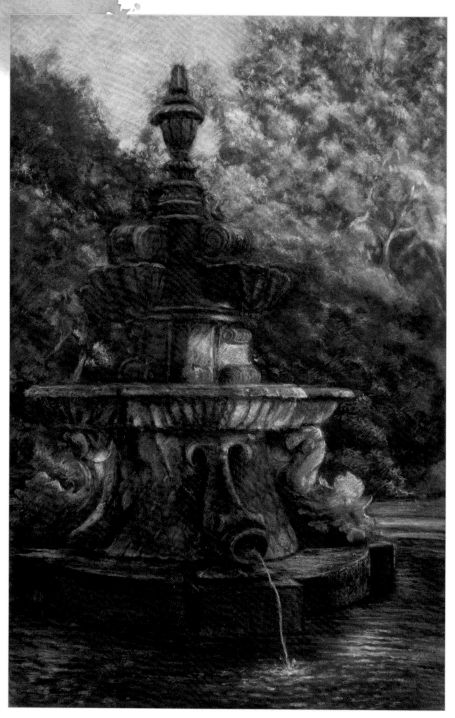

Sanded pastel paper, although costlier, is ideal for working with pastels.
The more texture the paper has, the better, due to the soft nature of pastels.

Artwork by Jim Dowdalls

OIL PASTELS

Oil pastels are compatible with almost any support. They are often used to accent or supplement other media; you can use them in conjunction with oil paint, as they respond to solvents, or even over dried acrylics or watercolor. You can also create wonderful works of art using only oil pastel.

RECOMMENDED SUPPORTS

- Any drawing paper
- Canvas
- Wood panel
- Stone, metal, glass, fabric, plastic

Note: You can manipulate the consistency of oil pastel with linseed oil and solvents used in oil painting. However, be sure to work on primed canvas, board, or sized paper.

OIL PASTEL ON PAPER

Oil pastel is very responsive to the texture of its support. Shown here is oil pastel on rough paper, laid paper, vellum-finish Bristol board, and toned pastel paper.

Rough Paper

Laid Paper

Vellum-Finish Bristol Board

Toned Pastel Paper

Drawing Media Comparison

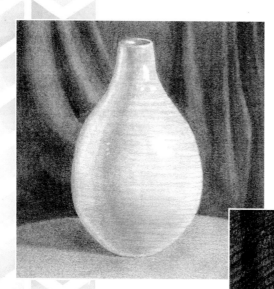

*Graphite on medium
drawing paper*

*Charcoal on gray
toned paper*

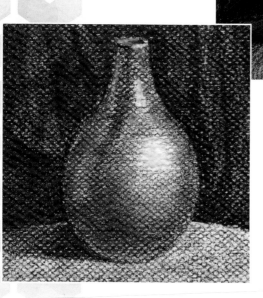

*Conté crayon on
textured cream paper*

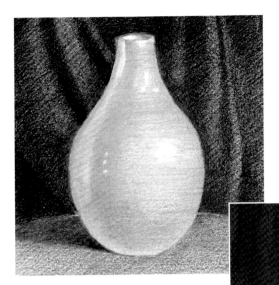

*Colored pencil on
medium drawing paper*

*Soft pastel on
textured blue paper*

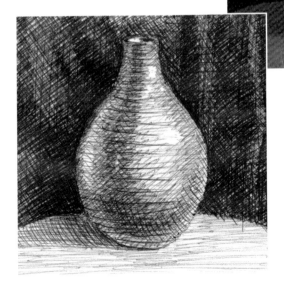

*Ballpoint pen on
medium drawing paper*

WATERCOLOR

Watercolor paper is available in myriad sizes, weights, textures, and formats. This specialty paper has been treated with sizing to reduce the absorbency of its surface. Secure the paper to a table or wooden board with artist tape or clips and work on a flat surface, which helps avoid unintentional runs and drips. If painting on the go, you can work on pads or in sketchbooks on your lap.

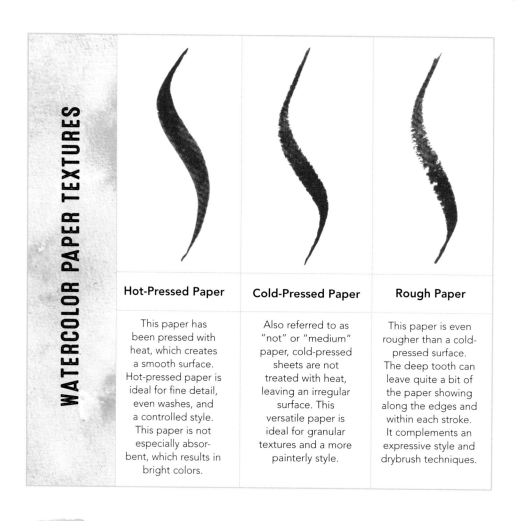

WATERCOLOR PAPER TEXTURES

Hot-Pressed Paper	Cold-Pressed Paper	Rough Paper
This paper has been pressed with heat, which creates a smooth surface. Hot-pressed paper is ideal for fine detail, even washes, and a controlled style. This paper is not especially absorbent, which results in bright colors.	Also referred to as "not" or "medium" paper, cold-pressed sheets are not treated with heat, leaving an irregular surface. This versatile paper is ideal for granular textures and a more painterly style.	This paper is even rougher than a cold-pressed surface. The deep tooth can leave quite a bit of the paper showing along the edges and within each stroke. It complements an expressive style and drybrush techniques.

TIP

The most forgiving surface for a beginning watercolorist is cold-pressed, hard-sized paper.

STRETCHING WATERCOLOR PAPER

Light- and medium-weight papers can warp when you apply wet paint, but they will stay flat if stretched first. This process is economical, as lightweight paper is considerably less expensive than heavy paper. Be sure to stretch well in advance of painting; the surface will take at least two hours to dry completely.

STEP 1

Prepare a sheet of watercolor paper, a board for securing it, a large tray of water, a sponge, and masking tape. Immerse the paper in the water briefly, turning it over to wet both sides evenly.

STEP 2

Place the wet paper on your board, leaving enough room to add tape along the edges. Use a damp sponge to smooth over the paper, removing creases and air bubbles.

STEP 3

Cut four pieces of tape that are slightly longer than the paper's edges and press them in place, smoothing them with your fingers. If using gummed tape, use the damp sponge to moisten the adhesive side before placing the strips. Allow to dry.

GOUACHE

You can paint with gouache on various papers—just remember that it's a water-based medium, so if you use a paper that is too thin, it will warp when water is added.

RECOMMENDED SUPPORTS

• Watercolor paper
• Heavy toned paper
• Illustration board
• Primed rigid surfaces

Thick paper is a great choice for working with gouache, because it will hold up to several layers of paint without warping. Textured paper will give your finished work a beautiful, natural feel.

Artwork by Joy Laforme

TIP

If you work thickly with gouache, it is best to choose thinner, rather than heavy, watercolor paper (at least 300 lb.) to reduce the risk of cracking.

ACRYLIC

Acrylic is the most versatile paint for fine artists and can be applied to a variety of surfaces, from watercolor and canvas paper to hardboard, wood, and traditional canvas. In fact, you can apply acrylic to any surface as long as it's not waxy or oily. This quality makes it a great choice for multimedia work and collage. When using acrylic in the style of oil, use an easel that props up your painting while you paint. If using acrylic as a fluid medium, work on a flat table to avoid unintentional drips and runs.

Many artists prefer to work with acrylic on toned surfaces. Toning refers to applying a layer of thin, transparent paint over the white of your surface. You might choose to do this for one or more of the following reasons:

- To establish a hue or hues that influence subsequent layers of paint, providing unity to the scene
- To establish a middle value that allows you to better judge the values of subsequent applications of paint
- To prevent distracting bits of white from showing through your final work
- To create interest in a background with subtle variations and textures
- To jump-start creativity and get past the blank white of your surface

Shown above is a canvas toned with pink, purple, and gold, along with its final painting (right). Notice how the original tone influences the finished work, creating a warm pink cast in the afternoon scene.

TONING THE CANVAS It's often best to tone the canvas with a transparent pigment. This will produce a luminous foundation that will help you create a sense of depth in the rest of the painting.

Artwork by Tom Swimm

OIL

Canvas and wood panel are the most suitable surfaces for oil painting. Remember that your surface must be sealed and primed properly to create a bright white ground, prevent impurities from leaching into the paint, and curb warping and rotting of the support. If your support is not pre-primed, you can apply sizing followed by oil or alkyd ground—or you can simply apply acrylic dispersion ground.

The slow-drying properties of oil paints allow you to create smooth blends and rework paintings over multiple sessions, allowing for an impressive degree of realism.

Artwork by James Sulkowski

TIP

Although it's not the best support for this medium, some artists enjoy the texture and drag of watercolor paper. If you choose to experiment with paper, it's best to use high-quality, heavy watercolor paper and prime it with a thin layer of acrylic gesso primer.

ADDITIONAL PAINTS

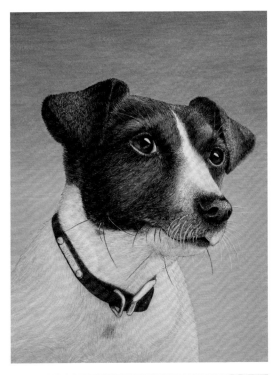

Egg Tempera Egg tempera paint pairs best with a rigid support, such as wood panel or claybord. This lovely semi-translucent paint dries almost instantly. Egg tempera is highly susceptible to cracking with age and requires a rigid surface.

Encaustic Encaustic painting involves hot, liquid wax and is best for use on rigid surfaces that are absorbent and heat resistant. Wood panels are a good choice, and you can also purchase Encausticbord™, a ready-to-use surface specifically designed for the unique demands of encaustic painting. If you're working with light layers or mixed-media techniques, flexible surfaces may also work. The key to working with encaustics is to test your wax on a new support type before beginning.

SURFACE PREPARATION

Most painting surfaces, such as wood, metal, and fabric, require preparation before you can paint on them. Without this step, paint may do one of the following: 1) fail to adhere, 2) peel away over time, 3) rot the underlying surface, 4) react with the surface to create discolorations, or 5) absorb into the surface too much and appear dull. A good primer can also provide a bright white base that yields true and luminous colors.

Primers come in a variety of containers, from cans, tubs, and tubes to squeeze bottles and spray cans.

Two basic substances you might use to prepare a surface are sizing and primer (or ground). The world of surface preparation is vast, and you'll find that product names and ingredients vary between manufacturers. The following pages offer an overview of the basics to help you better determine what category of product will work best for you.

SIZING & SEALANTS

Sizing serves as a barrier between the surface (or substrate) and the paint or primer, sealing the substrate so that oils cannot penetrate the surface. Canvas, paper, and wood panel are susceptible to rotting when exposed to oils over time, and sizing acts as their defense. Sizing also prevents oils from passing from the substrate into your paint, which causes discolorations. Note: You do not need to size a surface if you plan to prime with acrylic dispersion ground. (See "Acrylic Dispersion Grounds," page 98.)

Animal Glues Rabbit-skin glue and gelatin are considered traditional sizing for panels, canvas, and paper. If you choose one of these granulated options to create sizing, dissolve the powder overnight in a ratio of 1 part powder to 15 parts water. Then heat the mixture in a double boiler, brush the mixture thinly over the surface, and allow it to dry.

WARNING

When working with polyurethane, be sure to work in a ventilated area; wear a mask, goggles, and rubber gloves; and (when working with oil-based polyurethane) have thinners, such as turpentine or mineral spirits, on hand for cleanup.

Synthetic Sealants Many artists choose to seal their surfaces with newer synthetic materials, such as acrylic matte or gel mediums, which are flexible, effective, and generally nontoxic. PVA (polyvinyl acetate) dispersion also works well for panel, canvas, and paper, but be sure to use a PVA that is labeled acid-free (or neutral pH). Some artists use polyurethane to seal rigid panel surfaces.

PRIMERS & GROUNDS

Primer bonds with your support to create a new, more efficient painting surface that is porous enough to offer ideal absorbency and tooth.

Traditional Gesso The term "gesso" is often used loosely to describe any opaque white primer for painting. However, true gesso is made from gypsum, chalk, or marble dust mixed with rabbit-skin glue and white pigment. It is a luminous primer for rigid surfaces such as wood panels. Because it is not flexible when dry, don't use it to prime canvas or paper. Traditional gesso is not as readily available as newer primers, but you can find gesso mixing kits online and at some art-supply stores.

Foam brushes, house paintbrushes, and roller brushes (cloth or foam) are effective tools for applying acrylic dispersion ground. You can also scrape and spread grounds across surfaces using spatulas or even credit cards.

To apply gesso to a panel, heat it according to the manufacturer's instructions, and then follow "Applying Acrylic Dispersion Ground" on page 99. Keep these points in mind:

- Precede the gesso with a layer of sizing to seal the panel.
- Use a large bristle brush (or a house paintbrush) to apply the gesso in thin coats to reduce the risk of cracking.
- Four to as many as ten thin coats of gesso will result in a wonderful, marblelike painting surface.

TIP
The words "gesso" and "size" (referring to surface sealing) serve as both nouns and verbs. For example, you can apply gesso to a panel, and you can gesso a panel!

Oil & Alkyd Grounds Oil ground is an oil-based primer for canvas and panel that is designed to accept oil (but not acrylic) paints. It consists of linseed oil, chalk or gypsum, and white pigment.

A paint spatula can help you coat a surface with primer quickly and evenly.

Acrylic dispersion grounds are available in squeeze bottles, tubs, buckets, and even spray cans.

Alkyd ground is a resin-based primer with a faster drying time. If desired, you can thin oil and alkyd grounds with solvents such as turpentine or mineral spirits. Note: Due to the difference in drying time, do not use alkyd-based paints over an oil ground.

To use oil and alkyd grounds, precede application with a layer of sizing. Then use a palette knife or spatula to spread the ground evenly over your surface. Allow the primer to dry for a few days. (If using alkyd, the ground may dry within a few hours.) One to two coats are generally sufficient.

Acrylic Dispersion Grounds Sometimes called "acrylic gesso," acrylic dispersion ground or primer is a popular, inexpensive, versatile, and easy way to prime a paper, canvas, or panel. Similar to traditional gesso, it is a paintlike substance that you can apply to your surface in layers. Acrylic dispersion grounds come in white (used most often), gray, black, and clear. If desired, you can tint the ground your color of choice, using acrylic paint. Note: You do not need to apply sizing to a substrate before applying acrylic dispersion ground. However, to avoid possible darkening over time, first seal the surface with a layer of acrylic matte or gel medium.

You can use oil or acrylic paints over acrylic dispersion ground, although some artists choose to use an oil or alkyd ground under oil paints instead. Oil paints and acrylic ground respond a bit differently to temperature fluctuations, which may cause problems over time. Also, oil does not chemically bond to an acrylic surface, so be sure to leave some tooth on the surface and avoid sanding down your final layer of ground before applying oil paint.

WARNING

When working with primers, it's important to take proper safety precautions. Always work in a ventilated area and wear goggles, rubber gloves, and a mask, especially when sanding or working with lead-based oil grounds and solvents.

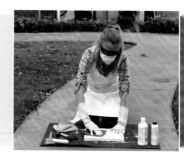

Applying Acrylic Dispersion Ground

STEP 1 If using a panel, such as this block of oak, sand the surface to remove any grooves, splinters, or textural irregularities. Wipe away the dust with a damp cloth.

STEP 2 Use a house paintbrush or roller brush to apply a layer of acrylic dispersion ground, starting at one end of the panel and working to the other end. Use parallel strokes that overlap slightly.

STEP 3 Wait for the gesso to dry and lightly sand the surface to smooth out any clumps or brushstrokes, if desired. Remove the dust with a damp cloth.

 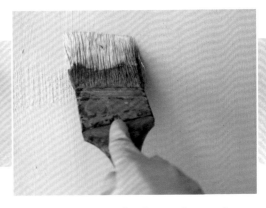

STEP 4 At a 90-degree angle to your first layer of strokes, apply another layer of parallel strokes. When dry, lightly sand the surface and remove the dust with a damp cloth. After you have applied two to four layers, lightly sanding after each layer, your painting surface is ready!

TIP: Using a house paintbrush to apply ground can create thick strokes with striations. Some artists like working on this texture, but others prefer to remove any remaining stroke textures once dry using fine-grit sandpaper. If the acrylic dispersion ground feels too thick for your liking, simply thin it with water.

TIP
If you want to texturize your painting surface, consider scratching, drizzling, or pressing coarse weaves (such as burlap) onto your final layer of ground.

Chapter 7:

Demonstrations

Now that you're equipped with the basics of various types of surfaces and the media they work well with, it's time to try your hand at working with different supports. Here you'll find a variety of step-by-step projects using different supports and media to create unique works of art—all presented by an accomplished selection of artists. This chapter features the following demonstrations:

- Graphite on Smooth Paper with Elizabeth T. Gilbert
- Alcohol Inks on Ceramic with Barbara Polc
- Acrylic on Panel with Blakely Little

GRAPHITE ON SMOOTH PAPER

with Elizabeth T. Gilbert

STEP 1

Begin by lightly laying in the basic shapes and outlines with an HB pencil, checking the proportions for accuracy.

STEP 2

Now stroke a layer of tone building the shadowed areas to suggest form. Use softer pencils for the darker areas.

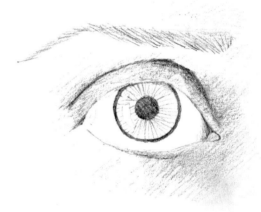

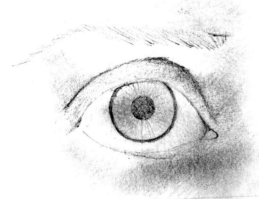

STEP 3

Blend the tone to create a smooth base that hints at the value pattern in the reference. Using chamois, blend the light skin surrounding the eye, and then switch to stumps for the darker, linear areas, including the eyebrow, crease, iris, and pupil.

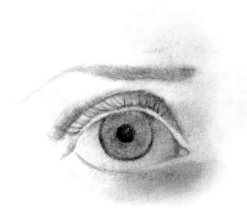

STEP 4

Because blending the tone lightens the overall value, reapply tone, blend, and repeat where needed.

STEP 5

Add fine lines and create highlights. Fill in the eyebrow with short strokes, using a 4B pencil and stroking in the direction of hair growth. Next switch to an 8B for the darkest accents, such as the pupil and eyelashes, blending subtly with a tortillon. Use a kneaded eraser to gently dab away tone to model the forms and soften any harsh edges. Then use a stick eraser to pull out the highlights in the iris.

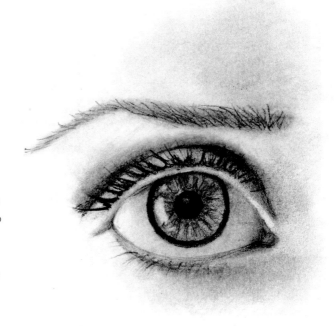

ALCOHOL INK ON CERAMIC TILE

with Barbara Polc

Alcohol ink is a fluid, vibrant medium that requires a nonporous surface. Ceramic tile is an excellent and economical substrate choice. The inks will mix and swirl, creating beautiful, ethereal backgrounds and images.

For this project you will need:

- Alcohol inks in various colors
- 91% isopropyl alcohol
- Smooth white ceramic tile
- Paper towels
- Small paintbrush
- Eyedropper or pipette
- Plastic paint palette
- Waterproof fine black liner pen
- Spray varnish/UV protectant sealer
- Optional: rubber gloves, cotton swabs

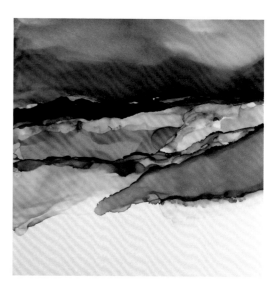

STEP 1: CREATE THE SKY

Clean a ceramic tile with a paper towel and 91% isopropyl alcohol. Let dry. Using an eyedropper (or pipette), apply a thin line of isopropyl alcohol to the top of your tile. Directly beneath this, apply a line of alcohol ink using the nozzle of the ink bottle. Tilt the tile from side to side, keeping the ink in the top third of the tile. When the desired effect is achieved, lay flat and let dry.

STEP 2: CREATE THE BACKGROUND

Apply alcohol ink below the sky, adding only a very small amount of isopropyl alcohol below the ink. Tilt the tile from side to side, or blow the ink gently with a straw, to create your desired background. Experiment with using multiple colors, if you wish. Applying the ink on an angle will produce interesting hills, mountains, or streams. Watch the beauty of the inks mix and swirl, creating new colors and shapes. Be sure to leave adequate room for your foreground.

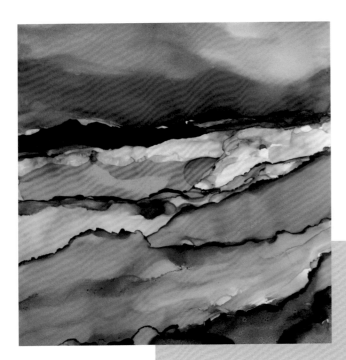

STEP 3: CREATE THE FOREGROUND

For the bottom of the tile, repeat the process described in step 2, using the colors of your choice. At this point, you can tweak anything you like by rubbing away ink with a paper towel and isopropyl alcohol to rework the area.

TIP

Using a small brush to move the inks creates interesting effects and works well to soften edges.

STEP 4: CREATE A FOCAL POINT

Dip a small brush or cotton swab in isopropyl alcohol and dab it off on a paper towel. Then wipe the ink off the tile to create a tree(s), sun, or moon. This may take several swipes. Be sure to rinse your brush in alcohol and dab it off on a paper towel after each swipe. Leaving some color in the tree(s) is helpful for the next step.

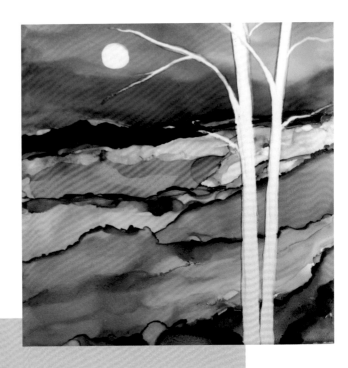

TIP

Too much alcohol on the brush or swab can cause excessive spreading of your inks.

STEP 5:
ADD DETAILS

To create foliage, load a fine brush with alcohol ink from the palette and dab it onto the tile to paint leaves. Use a waterproof fine-tipped black liner pen to add details to tree(s).

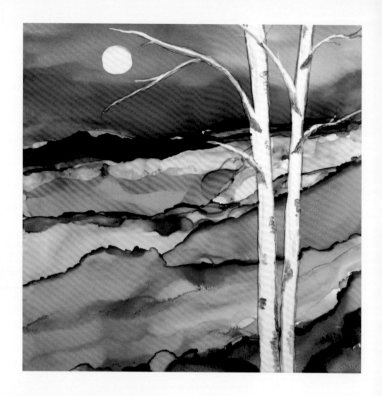

STEP 6:
PAINT THE TREES

Put a few drops of different colors of alcohol ink in the wells of a plastic palette and allow the inks to dry. Dip a paintbrush into isopropyl alcohol, dab off the excess, and dip the brush into a well of the palette, picking up the alcohol ink. Paint the tree(s) until you have reached your desired effect, and remember to rinse your brush in isopropyl alcohol in between ink colors.

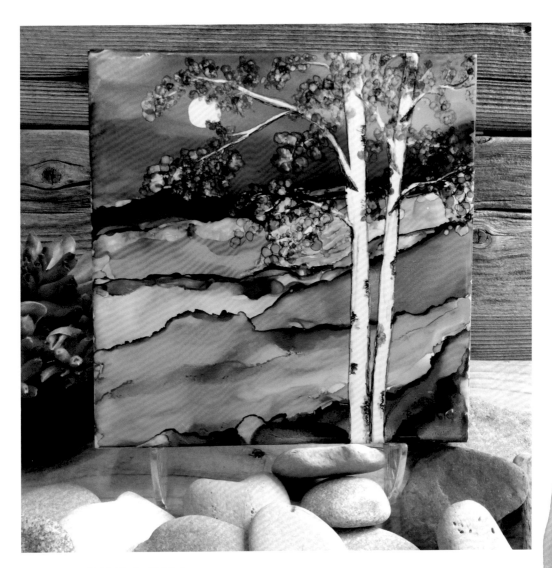

STEP 7: CURE & SEAL

Allow the tile to cure for five days. Then seal it with a spray varnish/UV protectant in a well-ventilated area. Seal your tile with several light coats of varnish, allowing for drying time between layers.

TIP

If you like, use a thick black waterproof marker to color the sides of the tile before sealing.

Acrylic on Panel

with Blakely Little

For this still life of oranges, let's use a bold complementary color scheme that is vivid and full of contrast. The surface used here is a birchwood panel, but you can use canvas or canvas paper if you prefer.

STEP 1

Start with a sketch from life to build the shapes and determine the shadows and highlights.

STEP 2

On birchwood panel, use yellow ochre to create an underpainting of the oranges from the sketch.

STEP 3

Mix navy blue, using ultramarine blue and Payne's gray, to paint the table. This color will make the orange look even brighter. Then add white to lighten the navy and fill in the back wall.

STEP 4

Use a medium orange color to work on the shapes of each orange. Using a flat paintbrush allows you to see the paint strokes, which help define the curves of the circular fruit.

STEP 5

Add white to the medium orange paint, and fill the insides of the cut oranges. Take a tiny dab of light orange and mix it with white to create the lightest shade of orange you can—almost white! Use a small filbert paintbrush for the reflections on the rinds of the whole oranges and to paint the membranes in the cut oranges.

STEP 6

Mix some navy with the orange and paint the shadows on the oranges; then dot where the stem once was. Use this color to roughly block in the cast shadows the oranges make on the table as well. With a stippling technique, use the lightest orange to create texture on the orange rinds. Finally, apply a wash of white on the background wall to show the light moving from one side to the other, making the right side brighter than the left side.

Conclusion

An exciting array of supports is available at your local arts-and-crafts store, but unlike pencils, paints, brushes, and mediums, you can gather art surfaces by thinking outside the box. You can search anywhere for the perfect support—from junkyards and thrift stores to your own garage. As long as you know how to prepare the surface for your medium, you will end up with some unusual and affordable options. Finding a drawing or painting surface can be like a treasure hunt—make it fun!

However, it's a good idea to stay aware of advancements in the field. Companies are always developing new surfaces that accept various art media beautifully and yield long-lasting artwork. Manufacturers are also tweaking paints and drawing tools to make them more versatile. This book offers a helpful starting point, but always keep growing as an artist!

ALSO IN THIS SERIES

978-1-63322-282-3

978-1-63322-272-4

978-1-63322-697-5

Quarto Knows

Inspiring | Educating | Creating | Entertaining

Visit www.QuartoKnows.com